A BRIEF HISTORY

of

PHOENIX

JON TALTON

THE
History
PRESS

Published by The History Press
Charleston, SC
www.historypress.net

Copyright © 2015 by Jon Talton
All rights reserved

Front cover skyline by Matt Ottosen | Ottosen Photography.

First published 2015

Manufactured in the United States

ISBN 978.1.46711.844.6

Library of Congress Control Number: 2015948830

For Susan

CONTENTS

ACKNOWLEDGEMENTS

In writing this work, I have depended on a rich body of scholarship about Phoenix, as well as the help of academics, archivists, urban activists and longtime residents. The three foundational scholars of Phoenix are Philip VanderMeer, William S. Collins and the late Bradford Luckingham. Each has produced one or more excellent works of history on the city and metropolitan area. Thomas E. Sheridan's book *Arizona: A History* is the best single-volume history we have yet about the state. We are all in debt to Thomas Edwin Farish, who was commissioned by the legislature soon after statehood to write a multi-volume history of Arizona. Farish, who knew many of the pioneers personally, remains a rock-solid source. The definitive examination of Phoenix's sustainability and environmental issues comes from Andrew Ross. Jack August Jr. has brought his wide-ranging talents to a number of Phoenix and Arizona projects but is especially valuable in chronicling water issues. August was unfailingly helpful and patient in answering my questions.

I am in debt to Rob Spindler, university archivist and head of archives and special collections at the Arizona State University Libraries. He was especially helpful in guiding me through thousands of photographs in the university's collection. Other photographic help came from Michael Ging, Brad Hall and Jeremy Rowe, as well as Wendi Goen of the Arizona State Archives. Professor David William Foster at ASU provided insights into Phoenix's barrios, Hispanic art and visual and written representations of the city. Will Bruder deepened my understanding of the city's architecture and design. The Phoenix Police Museum was helpful in detailing some of

the city's law enforcement and crime history. I've spent most of my adult life looking through the archival treasures of the Phoenix Public Library's Arizona Room; it is an amazing resource.

While I was a columnist at the *Arizona Republic* from 2000 to 2007 and afterward writing the blog "Rogue Columnist," I benefited from conversations and interviews with so many who helped me understand Phoenix's past, present and potential futures. I am especially grateful to Jim Ballinger, Betsey Bayless, John Bouma, Alan Brunacini, Don Buddinger, Reid Butler, Sam Campana, Chad Campbell, Jose Cardenas, Jerry Colangelo, Lattie Coor, Michael Crow, Cindy Dasch, Karl Eller, Nan Ellin, Roy Elson, Greg Esser, Jonathan Fink, Grady Gammage Jr., Neil Giuliano, Terry Goddard, Phil Gordon, Pam Goronkin, Alfredo Gutierrez, Walt Hall, Art Hamilton, William Harris, Dan Hunting, Kimber Lanning, Cal Lash, Richard Mallery, Carol McElroy, Pat McMahon, Jim McPherson, Rob Melnick, Ioanna Morfessis, Margaret Mullen, Mark Muro, Naaman Nickell, Jim Pederson, the late Jack Pfister, Elliott Pollack, Wayne Rainey, Skip Rimsza, Claire and Henry Sargent, Dan Shilling, Greg Stanton, Bill Stephens, Jeffrey Trent, Feliciano Vera, Mary Jo Waits, Quinn Williams, Ed Zuercher, the late John J. Rhodes and the late Newton Rosenzweig.

Megan Laddusaw of The History Press approached me about writing this book, and I appreciate her professional skill, care, good cheer and patience, as well as that of her colleagues.

I was fortunate to have Marshall Trimble, who spent years as Arizona's official state historian, as one of my teachers at Coronado High School in Scottsdale. He helped stoke my lifelong appetite for local and state history. So did my mother, Vivian Talton, and grandmother, Ella Darrow Hammons, who lived much of it. The author Tom Zoellner encouraged me to move from journalism and fiction to writing a history of my hometown. His example is an inspiration. I am most grateful to my wife, Susan Talton, who fell in love with Phoenix and me, despite our flaws and paradoxes.

A note on language: to be true to local convention, I refer to all whites as "Anglos."

SO BIG

In 2006, the census bureau reported that Phoenix had overtaken Philadelphia to become the nation's fifth most populous city.

This was quite an accomplishment for a place that had barely entered the ranks of the one hundred largest cities in 1950, at number ninety-nine. Other American cities, such as Chicago in the late nineteenth century, had grown faster. But none was in such a hostile environment and isolated location. None among the very biggest was so relatively young. Phoenix was settled in the late 1860s but didn't become what would be considered a big city until 1960, when its population was 439,170 and it ranked number twenty-nine. The only one close was Oklahoma City, settled in 1889 and, thanks to its oil boom, a sizable city three decades earlier than Phoenix. But by 1960, Oklahoma City ranked only thirty-seventh in population. When the census made its 2006 estimate, Phoenix was about three times the size of its nearest cousin among young cities.

Some say that all Phoenix ever wanted was to get big. While an oversimplification, the statement carried some truth. Generations of Phoenix boosters, builders and visionaries imagined that a tiny farm town would become a large and great metropolis. Especially in the decades after World War II, the city became obsessed with population numbers to the exclusion of almost all other measurements. And they had always continued to grow. Census numbers, whether estimates or the hard data every decade, had a talisman quality. This was not merely because they determined the amount of federal money that would flow to the city. More importantly, they

validated the city's seeming perpetual motion machine where growth not only appeared to pay for itself but also was a feedback loop of prosperity. More than 100,000 people arriving every year to the metropolitan area provided seemingly indisputable validation.

For a moment, even some hardened local skeptics had a difficult time denying the success. America's largest cities were New York, Los Angeles, Chicago, Houston and now Phoenix. For members of the city's business and political elite, the moment carried a sense of inevitability. This was certainly the mood among a delegation of Phoenix leaders invited to the City of Brotherly Love, where they were greeted generously and with no small amount of envy. Phoenix was, the Philadelphians gushed, so new and clean, its government businesslike and efficient and the economic wind was at its back. None of the guests disagreed, for the essential characteristic of Phoenicians is optimism, where the future is always a rising path.

The reality was more complex. Indeed, the gathering economic bubble and Great Recession would shatter Phoenix, sending it into its worst times since the 1890s. But that was a couple years away and only a relatively few people saw it coming, much less dared to warn others about it.

Also, aside from a few familiar metropolises, the list of top ten cities had been remarkably fluid. In 1900, when only three American cities boasted populations of more than one million, Boston had been number five. Three decades later, the spot had been seized by Los Angeles and, by 1950, Detroit. When Phoenix reached the ranks of the biggest ten, former members had fallen far: Buffalo, Cincinnati, St. Louis—the Phoenix suburb of Mesa had more people than these cities. Nor did population alone provide a particularly complete or useful guide to a city's fortunes or livability. Phoenix's boosters were undaunted, anticipating the time before Houston fell behind the juggernaut in the Sonoran Desert. Almost all plans seemed predicated on a doubling of the metropolis's population within a few short decades.

This shining moment was somewhat dampened by the reaction of many people around the country. Phoenix? The nation's fifth largest city? You can't be serious.

Most people outside Arizona knew Phoenix as a vacation spot with sun-bathed resorts, baseball spring training and golf; a retirement mecca, one of the many beneficiaries of the great Sun Belt migration; the home of Barry Goldwater and one of the birthplaces of modern conservative politics. In recent years, it has gained notoriety for spectacular images of giant dust storms descending on the city, a timeless part of the region's monsoon season but new to most television viewers nationally—and with the exotic

name "haboob" attached (a word most Phoenicians didn't use in the past). Most Americans didn't realize how enormous Phoenix had become, with 1.5 million people in more than five hundred square miles. And this was only within the city limits. Surrounding Phoenix were highly populated suburbs—boomburbs, supersuburbs, edge cities—that had the metropolitan population headed toward 4 million. Still, when I would mention these numbers to friends who lived elsewhere, they would invariably say, "I had no idea Phoenix was so big."

By the 2010 census, Philadelphia had grown just enough, and Phoenix's growth had slowed just enough, that the two reversed positions for the moment. Phoenix was the sixth largest city in America. Even so, when I tell this to many people around the country, they are still incredulous that Phoenix is even number six—ahead of San Antonio, San Diego, Dallas and San Jose. It was the center of the nation's thirteenth-largest metropolitan area and seat of its fourth most populous county.

Explaining how and why Phoenix became so big is one of the goals of this book. In addition, it is intended as a concise corrective for many Phoenicians who say the place "has no history." For hundreds of thousands of newcomers who move there yet still consider "home" back in the midwest, it might even seem that way. They buy houses in new developments on the metropolitan fringes, shop at sparkling malls and speed along an extensive freeway system. While they might dabble in some of the cowboy lore of Arizona, they know next to nothing about the city's past. This lack of knowledge is supercharged by population churn: large numbers of people come to Phoenix, but large numbers also depart. What does such a transient city have to teach?

Yet Faulkner's "The past is never dead. It's not even past" could have been custom written for Phoenix. For all the patina of ultramodernity in a postcard desert setting, this is a place with a rich and compelling past. Understanding Phoenix's present, including how its challenges are of profound importance to the entire nation, requires grappling with its plentiful and conflicted past.

Phoenix is one of the great accomplishments of American civilization. Beyond that, we must navigate extreme paradox. While it is our newest major metropolis, it is built atop the ruins of a once-populous area of prehistoric settlement. One would not be stretching the facts much to say Phoenix is America's youngest and oldest city, and the contradictions don't stop there. For all the self-image of rugged individualism and criticism of big government, Phoenix owes its life to both collective effort and federal investment. Phoenix faces serious water challenges but has plenty of water.

It is a city of clean slates and fresh starts yet also imposes subtle but real restraints and has a background of injustice, exclusion and corruption. It is an oasis in an arid wilderness, nature apparently harnessed for human bidding and yet in reality dangerously untamed. Phoenix is ambitious and lazy, visionary and prone to the short hustle, on the leading edge and embarrassingly behind, an open book and yet very hard to read. All this, and Phoenix is now so big.

Here is how it happened.

REBORN

When John William Swilling was born in 1830, the future site of Phoenix was two thousand miles away, deep inside Mexico in a forbidding and mysterious wilderness.

The Coronado expedition of 1540–42 had swung far to the east. Father Eusebio Kino had established the San Javier del Bac mission, about 125 miles south, in 1700. Spanish soldiers under command of the Irishman Hugh O'Conor had built a presidio, or fort, that came to be named Tucson seventy-five years later. But this was as far as the Spanish, and later the Mexicans, dared go. Their sometime allies, the Pima and Maricopa, occupied farming villages on the Gila River, slightly south of the present-day Phoenix metropolitan area, but they faced periodic attacks by Apaches who controlled most of the territory farther north.

Swilling, the man most responsible for founding Phoenix, came into this world on a plantation in Anderson County, South Carolina. His father, George Washington Swilling, managed the property and eventually came to own it. The family moved to Georgia when John, who went by Jack, was fourteen. Many, although by no means all, Anglo Americans were beginning to embrace Manifest Destiny, the belief that the United States was providentially ordained to control the continent from the Atlantic to the Pacific.

Carrying this out would require the peaceful submission by, or violent conquest of, hundreds of native tribes. America's continental empire of liberty also co-existed with a republic of bondage, where millions of Africans

were enslaved in twelve slave states, half the Union. Even the free states prospered from slave-picked cotton, the foundation of the northeast's textile industry and the nation's most valuable export.

Both Manifest Destiny and the South's desire to extend slavery led to the Mexican War. Seventeen-year-old Jack Swilling enlisted in a unit of Georgia volunteers that fought in this deeply divisive conflict. The United States victory brought a huge cession of land from Mexico, including most of today's Arizona. The Gadsden Purchase of 1853 added southern Arizona below the Gila and a piece of southwest New Mexico. Again, it was a move driven by southern interests, especially Secretary of War (and future Confederate president) Jefferson Davis. The South insisted on its own southern transcontinental railroad route.

By the late 1850s, Swilling was in Arizona (which at the time was part of New Mexico territory), working as an Indian fighter and prospector, where he made several important gold discoveries. The historian Daniel Walker Howe wrote of the era: "This was not a relaxed, hedonistic, refined or indulgent society…The man who got ahead in primitive conditions did so by means of innate ability, hard work, luck and sheer will power." It was even truer of the Anglos making inroads in Arizona, in the mineral rich north-central highlands around the future Prescott and in Tucson. Howe could have been writing about Swilling.

When the Civil War came, the Confederacy established Arizona Territory in the southern half of Arizona/New Mexico. Not surprisingly, Swilling joined the Confederate Arizona Guards militia and was elected first lieutenant, the second in command. After Union forces defeated the Rebels and took the territorial capital of Tucson, Swilling deserted rather than follow orders to confiscate cattle and supplies from his neighbors. He quickly became of use to the Union in fighting the Apaches and acting as a courier. He established friendships and business ventures with Union officers. Discovering gold between Wickenburg and Prescott, he gave samples to General John Henry Carleton, who forwarded them to President Abraham Lincoln. The U.S. Arizona Territory was established in 1863.

Returning to Tucson, Swilling married for the second time (his first wife died), to Trinidad Escalante. The two would have seven children and adopt two Apache orphans. But in September 1867, he ventured north to the Salt River Valley, a place that had been virtually uninhabited for four hundred years. There he befriended John Y.T. Smith, a former Union officer who was farming hay to supply the army's new post at Camp (soon Fort) McDowell, northeast at the Verde River. Smith built the first house in the valley, around

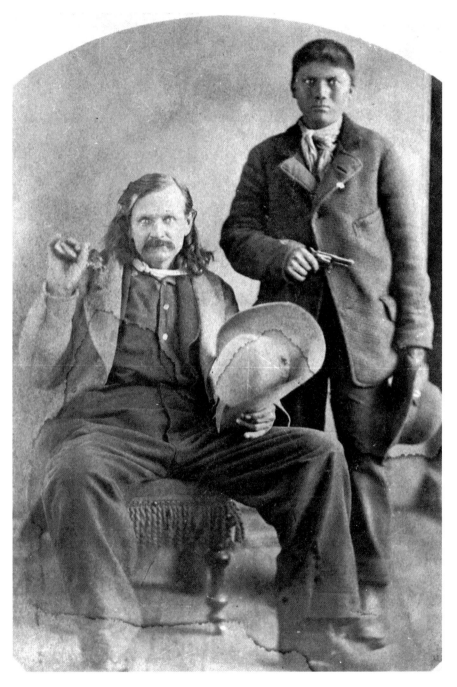

Jack Swilling, seated, in the 1870s. The man standing is likely his adopted Apache son. *Arizona State Library, Archives and Public Records, History and Archives Division, Phoenix.*

the location of today's Sky Harbor International Airport. But it was Swilling who saw something much more.

Although previous travelers had noted the prehistoric ruins and canals, Swilling, with the farming background of his youth, recognized the rich alluvial soil of the valley and the possibilities of irrigation. The canals were more than a curiosity. As pioneer-era historian Thomas Edwin Farish wrote, Swilling "was impressed with the many possibilities attending the irrigation of this fertile valley, which appeared almost level, with the waters of the Salt River flowing through it. It seemed an easy task to throw these waters over the fertile desert, which was all that was necessary to make this desert valley blossom as a rose." Crops could supply mining settlements dependent on food brought at high cost from California and Mexico.

In Wickenburg, Swilling convinced a group of men to invest in the Swilling Irrigating Canal Company. And in December 1867, they started clearing out some of the prehistoric canals and digging the Swilling Ditch. This group—named by Farish as Peter Barnes, Jacob Denslinger, Brian P.D. (Darrell) Duppa, Thomas J.L. Hoague, James Lee, John Larsen, Frank S. Metzler, Thomas McWilliams, Thomas McGoldrick, Michael McGrath, Antonio Moreas, James Smith, Lodovick Vandermark, P.L. Walters and Joseph Woods—can lay claim as Phoenix's first settlers. By the summer of 1868, barley and corn were harvested.

Yavapai County authorities formally recognized the town on May 8, 1868, with the establishment of a voting precinct. In June, a post office was placed there with Swilling as postmaster. The settlement had several early names, Swilling's Mill, Mill City—Swilling himself wanted to name it Stonewall, after General Stonewall Jackson. In 1870, when the original half-square-mile town site was laid out farther west, the classically trained, English-born Darrell Duppa, who went by "Lord Duppa," picked the one that stuck: Phoenix. The image of the bird from mythology fit the place being reborn on the ashes of an ancient settlement. The new town had approximately 250 residents farming 1,500 acres. It became the seat of a new county, Maricopa, in 1871. The town's first school began classes that same year. By 1872, "Big Mike" Goldwater, grandfather of a future U.S. senator, opened his store there, joining other merchants.

Jack Swilling became an uncomfortable founding father for Phoenicians who wanted their town to quickly become respectable, modern and "American." Thomas Sheridan offers the common verdict among historians, "Swilling was a morphine addict and a violent drunk, who died in a Yuma prison in 1878 after being accused of robbing a stage." As a Confederate

deserter, Swilling was anathema to the many southerners who settled in Phoenix. Someone such as the upright Smith, who became speaker of the Territorial House of Representatives, would better fit the bill.

But Swilling deserves better. A physician apparently first prescribed the morphine after he had been injured in an attack. Alcohol was one of the fuels of western settlement, and Americans drank enormous quantities. Contemporaries remembered Swilling, Farish wrote, as "a kind-hearted, generous man, public spirited and always ready to assist any needy man." From prison, Swilling wrote a letter to the *Prescott Miner* newspaper. His wounds, he wrote, "sometimes still drive me crazy." His addictions "made me mad" and prone to "periods of debauch." After he died, it was proved that Swilling had no connection to the robbery.

Indeed, Swilling is the appropriate First Phoenician. Critically, he understood the potential of the Salt River Valley and acted on it. He was visionary, audacious and enterprising. He crossed a continent to practice unceasing self-reinvention in this new place, this blank slate. He came from a culture of white supremacy but created a multicultural family. Swilling's joint-stock canal company provided the prototype for other water projects. He made money and lost it, boomed and busted. Manifest Destiny and the sensibilities of the South were with him, and well through the first half of the twentieth century Phoenix would be a southern, as well as a western, city. And like that city, his devils would always be at war with his angels.

AMERICAN EDEN

S willing and the early pioneers chose well. The Salt River Valley, fifteen miles wide and running fifty miles from east to west then opening on a broad basin, was one of the most well-watered places in the west. Four rivers converged here, draining a watershed of thirteen thousand square miles fed by mountain snowmelt. The Salt ran with water year-round. Phoenix was a true oasis, graced with cottonwood, willow, ash, mesquite and other native shade trees. It lies in one of the great alluvial valleys of the world. Almost anything will grow here—just add water. Despite searing summer heat, the Sonoran Desert is one of the wettest deserts on the planet, with more than 3,500 species of animals and plants.

The "ashes" of Duppa's Phoenix were the remains of the Hohokam civilization, which occupied the Salt River Valley for one thousand years or more. Digging one thousand miles of canals and ditches to bring river water to their crops, the Hohokam built the most advanced irrigation society in the pre-Columbian New World. At its high point, around the eleventh century, the society supported as many as fifty thousand inhabitants.

In 1888, anthropologist Frank Hamilton Cushing made the first professional dig and yet our understanding of the Hohokam continues to evolve. The key question is, what caused them to leave the fertile valley? Archaeologists continue to argue over what drove the tipping points. A severe drought followed by canal-wrecking floods was one major cause. But the society was also under increasing stress from salinization of the soil, over-hunting of native animals, immigration from other tribes and a breakdown

of cooperation and authority. The decline of the Hohokam may have taken three centuries or more, but by the time Columbus arrived in the New World, they were gone from the valley. The Pima, likely their descendants, applied the name *Huhu-kam*, "all used up."

The American settlers knew little of this, nor would it have deterred them. The great, post–Civil War westward migration was underway. Arizona Territory was a rough and dangerous place, dependent on extracting minerals or the business of cattle grazing, which offered limited opportunities. Much of it was the Wild West, epitomized by Tombstone. The Salt River Valley offered something different—two growing seasons in a rich tableau for civilizing agriculture. Farming meant something very different in the nineteenth century than it does today. Most Americans lived on farms. To till your own land meant independence and the chance not only for self-sufficiency but also to sell crops as a livelihood. Jefferson believed the yeoman farmer was the bedrock of American democracy. Although Phoenix remained very isolated, blocked from the east and north by high mountains and facing a daunting desert to the west, it was the site of the richest large stretch of farmland between the 100^{th} meridian and the fertile regions of the West Coast.

Swilling's Ditch, soon called the Town Ditch, was only the beginning of a vast plumbing project that would continue to be built for decades. Wells were also dug for potable water. Land was platted from the Gila and Salt River Baseline and Meridian, and more ditches were excavated. Wheat and grains were the early crops, followed by beans, corn, sweet potatoes, grapes, sugarcane and a variety of vegetables and tree fruits.

Former Union officer William John Murphy, backed by some of the most prominent people in the territory as well as eastern capital, led building of the ambitious Arizona Canal between 1883 and 1885. Starting upriver from the Hohokam canals and running forty-one miles, it opened up much more land. His construction foreman was John R. Norton, who would become the patriarch of a farming and ranching dynasty. In the late part of that decade, the Reverend Winfield Scott, an army chaplain, acquired 640 acres. With his brother George, he planted the first citrus trees, along with dates and figs and other tree crops. By 1890, 125,000 acres were under cultivation in the valley.

One year earlier, the territorial capital had been moved from Prescott to Phoenix. Although this was partly the territorial legislature's solution to intense competition between the two population centers of Prescott and Tucson, Phoenix farmers and business interests had been lobbying hard for

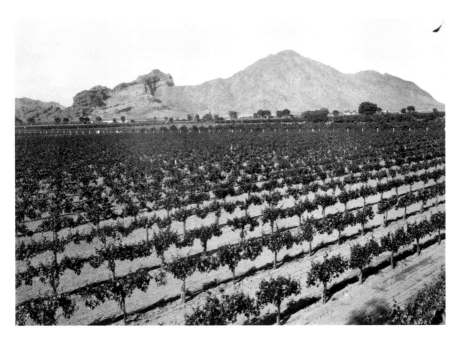

Grape vineyards with Camelback Mountain in the distance. *Library of Congress.*

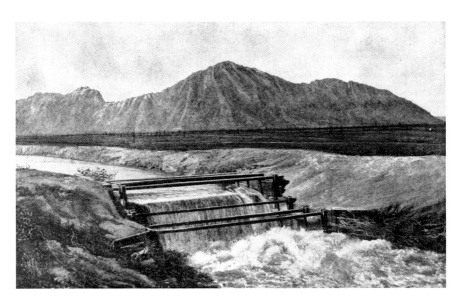

The Crosscut and Arizona Canals, 1893. Early settlers cleaned out the old Hohokam canals and built new ones to divert water from the Salt River. *Library of Congress.*

it for a decade. "The struggle over the capital reflected emerging problems within the territory as well as illustrated how shifting growth patterns shaped political destiny," historian Jack August Jr. told me. But "one cannot overemphasize the development of large-scale irrigated agriculture in the 1880s, which certainly facilitated unprecedented population growth that propelled Phoenix to the political forefront."

With expanding agriculture came what economists today would call an "ecosystem" of support businesses, banks, professionals, stores and other commerce to Phoenix. The first newspaper, the *Salt River* (soon *Phoenix*) *Herald*, opened in 1878. Phoenix incorporated in 1881 with a population of 1,700 and, as historian Philip VanderMeer points out, fifteen saloons. The policing of "Whiskey Row" and elsewhere fell to the popular Enrique "Henry" Garfias, who was elected town marshal. A Methodist circuit rider arrived from Los Angeles, and soon the Central Methodist Episcopal Church, South was established. Catholics founded St. Mary's Church in 1881. The decade would see the opening of an opera house, the establishment of a volunteer fire department and the chamber of commerce and granting of a franchise to the Phoenix Illuminating Gas and Electric Company.

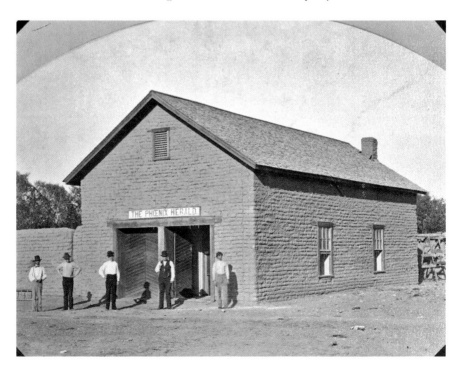

The town's first newspaper, the *Phoenix Herald*, 1879. *Library of Congress.*

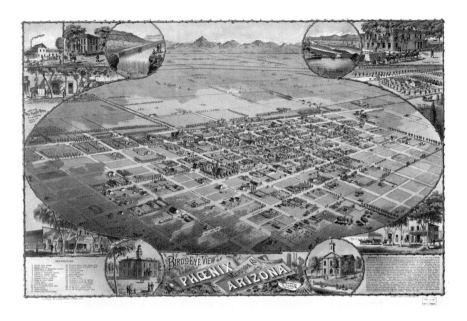

Illustration showing a bird's-eye view of the original town site, 1885. *Schmidt Label & Litho Co., Library of Congress.*

Even with the growing features of a town and a reputation as the most peaceful place in the territory, Phoenix was still a rough place. Men drank to excess, many were armed and violence was not uncommon. Sometimes impatient citizens sought their own rough justice. One example was the August 1879 lynching of two alleged murderers by a law-and-order committee, formed by nearly two hundred people. As journalist Earl Zarbin later wrote, "This was no mob shouting for vengeance; the group was composed of some of the town's best citizens and their demeanor was purposeful and businesslike." The sheriff and most of his deputies abandoned their duties, leaving the prisoners to the "committee." They were hanged in the town plaza before a crowd estimated at four hundred or more. At least sixteen men were lynched in early Phoenix.

A transformative achievement came in 1887, when a branch of the Southern Pacific Railroad arrived, ending the town's isolation and opening vast new markets for Phoenix's produce. The Santa Fe Railway, building from the north through Prescott, reached the town in 1895. The railroads did more than haul crops. They began aggressive promotion of the valley to potential settlers and capitalists in the east. Phoenix went by many names, "Grain Emporium of Arizona," "Garden Spot of the Territory," "The American Nile" and "American Eden."

Looking east along Melinda's Alley near Montezuma (now First) Street and Monroe, 1898. *Collection of Jeremy Rowe Vintage Photography; Vintagephoto.com.*

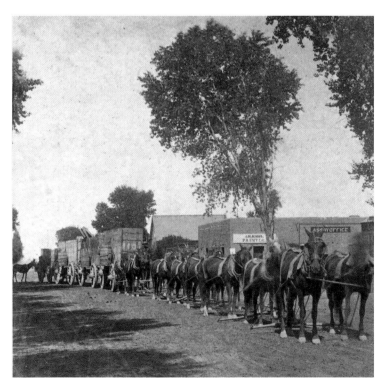

Horse teams moved freight before railroads reached Phoenix. This photo is circa 1880. *Collection of Jeremy Rowe Vintage Photography; Vintagephoto.com.*

More irrigation work was done south of the Salt River as Mesa was founded by Mormon pioneers in 1878. A year later, Tempe, where Hayden's Ferry traversed the river, was founded. It was followed by Glendale (1887), Peoria (1897) and others. By 1890—the year the census bureau stated the frontier was settled—eleven thousand people were in the valley. A long rivalry also began between water users on the north side of the Salt River, especially Phoenix, and those on the south in Tempe and Mesa.

The federal government further encouraged settlement, a recurring theme in Phoenix history. By 1886, the army forced peace on most of the Apache and Yavapai bands that had controlled the lands north and east of Phoenix, making travel perilous. The Desert Land Act of 1877 expanded the Homestead Act's 160 acres, allowing settlers to purchase 640 acres for $1.25 an acre if they could irrigate them. Even so, settlement was not neat. Land fraud, a recurring Arizona problem, began early, and land and water rights would be disputed for decades. Land speculation, another defining feature of Phoenix, also got its start at this time, especially with land adjacent to the Arizona Canal. To be fair, this was the Gilded Age, where fraud and

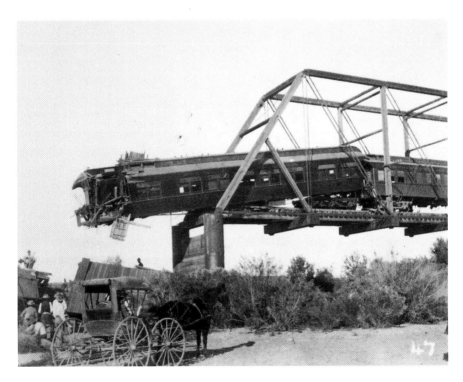

A railroad car hangs from the bridge washed out by the 1902 flood. *Library of Congress.*

speculation were commonplace everywhere. In the west, migrants were often lured to a promised garden spot only to find a bleak expanse. If anything, the Salt River Valley offered a better shot, especially for Anglos.

Whatever else it became over the following decades, Phoenix was foremost the center of an agricultural empire. But securing that would require more than dependence on the wild rivers and commercially developed canals.

The 1890s nearly broke the dream of Phoenix. Severe floods, beginning with a mammoth 1891 torrent, wrecked diversion dams and canals, as well as swamping crops. Then came ten years of drought followed by another flood. Back east, the United States suffered a severe depression brought on by the panic of 1893. Three years later, the Arizona Canal Company was forced into receivership. Floods were nothing new to Phoenicians; the wide, meandering river had run wild in 1868, 1874 and 1884. It was no coincidence that the original town site was located one and a half miles north of the Salt. But they had never encountered anything like the bleak nineties. To the historically minded, it seemed as if the Anglo Americans were following the doomed ghosts of the Hohokam.

RECLAMATION

The oldest known dam of significance was built around 3000 BC in what is today's Jordan. Almost 15 feet high and 260 feet across, the Jawa Dam was likely part of several such structures that were meant to hold water of the infrequently running Wadi Rajil. The Romans were great dam builders, and the technique advanced substantially in parts of the British Empire of the nineteenth century. In all these cases, the goal was to control the stream much more fully than the primitive diversion dams of the Hohokam and the early American settlers of the Salt River Valley.

By latter decades of the nineteenth century in America, some scientists and engineers saw rich potential for dams as part of settling the west. Foremost among them was John Wesley Powell, who had lost an arm at the Battle of Shiloh in the Civil War. He led the first party of Americans on the risky boat expedition down the Colorado River and into the Grand Canyon in 1871–72. Appointed second director of the U.S. Geological Service, Powell wrote the influential *Report on the Arid Regions of the United States*. He advocated cooperative efforts to create irrigation districts in the west and use dams to open up huge regions of the nation through public reclamation. Another supporter was Frederick Newell, Powell's aide, who would go on to become the first director of the U.S. Reclamation Service.

Without Washington's involvement, they argued, few places could afford to dam rivers. The evidence backed them up. Among the first dams was the 140-foot-high Crystal Springs Dam, built across San Mateo Creek in 1888 to provide water for the city of San Francisco. Sweetwater Dam was

completed to serve San Diego. The following year, private interests built the shorter Banning Dam across Eleanor Creek in Southern California. But for the most part, the rivers of the American west ran wild, and Phoenix seemed to have little chance to muster the wealth or political clout to match the accomplishments of the rich state of California.

Yet in 1888, as San Francisco was celebrating its dam, Maricopa County officials commissioned the county surveyor, William Breakenridge, to seek out the best site for a dam and reservoir site upstream on the Salt River. Accompanying him were John R. Norton of the Arizona Canal's parent Arizona Improvement Company and Colonel James McClintock of the *Phoenix Herald* (and a future Rough Rider). More than seventy miles northeast of Phoenix, they found an ideal spot, a canyon with high, narrow walls near where Tonto Creek flows into the Salt River.

However solid the Breakenridge survey was, however much the technology of the Americans surpassed that of the Hohokam, actually building that dam seemed impossible. Private capital was not forthcoming despite an abortive effort by the Hudson Reservoir and Canal Company, which opened a Phoenix office in 1894. Even if the privately financed project had been practical, the national financial troubles of the 1890s made selling bonds almost impossible. Nor was this the only impediment. Private interests that already controlled water rights opposed the kind of common effort advocated by Powell. The canal and water companies south of the Salt River and in the Buckeye basin farther west of Phoenix were suspicious of the water-rights holders north of the river and the town of Phoenix. Reclamation advocates and irrigation interests were divided elsewhere, too, and Washington, under the Cleveland and McKinley administrations, was suspicious of committing federal funds to such quixotic ventures. Many Arizonans, likewise, opposed federal intervention in matters they believed rightly belonged to a place they hoped would soon become a state. Further progress would have to wait.

Amazingly, considering the difficulties of the 1890s, the town's population reached 5,544 by 1900, an increase of nearly 76 percent. Maricopa County's population rose more than 86 percent to 20,457. The town boasted seventeen churches, thirty-three saloons and the new Phoenix Country Club. In addition to the arrival of the Santa Fe Railway, the decade would see the federal government establish the Phoenix Indian School. Also, hotelier John Adams arrived and built the finest hotel in the territory, the multi-story Hotel Adams (it burned in a spectacular 1910 fire but was immediately rebuilt as a "fireproof" hotel). In 1897, the first telephone service began. Phoenix also enjoyed a growing streetcar system, with cars first towed by

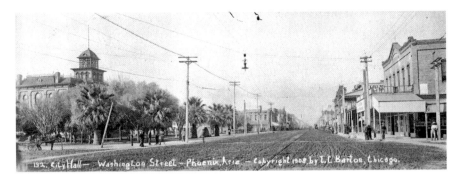

Washington Street in 1908, with Phoenix City Hall at left. *Lester Barton, Library of Congress.*

Memorial Hall at the Phoenix Indian School. *Library of Congress.*

horses and then powered by electricity. Lines ran through the central business district east as far as the state insane asylum at Twenty-Fourth Street, west to the territorial capitol building, north through new neighborhoods as far as the Indian school and a northern loop that ended in Glendale.

City and territorial leaders saw constructing a capitol as an important sign that Arizona was ready for statehood (the legislature had been meeting in

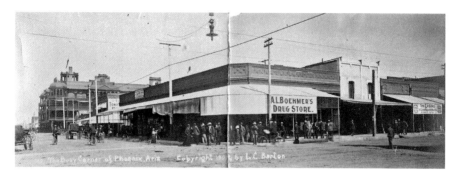

Center Street, 1908, before being renamed Central Avenue, where it meets Washington Street. The imposing building at left is the first Hotel Adams, which would burn two years later and be replaced by a "fireproof" Adams. *Lester Barton, Library of Congress.*

the county courthouse). Texas architect James Riely Gordon won a design contest with a handsome building set off by a large rotunda and wings for the legislature. However, as would happen frequently in Arizona history, funds were cut back, and the final design, while charming with a small copper dome, was modest. It would remain the state capitol building for decades and never be superseded by something more inspiring. The new capitol opened in 1901, and Phoenicians celebrated their most impressive public building. But the town's prospects for continued growth looked dim if the cycles of destructive flooding and drought continued.

A year into the new century and nearly a continent away, Buffalo, New York, was holding the Pan-American Exposition, a world's fair showcasing what was then the nation's eighth-largest city. On September 6, 1901, President William McKinley visited, just months into his second term and enjoying his popularity from the Spanish-American War. In the Temple of Music, an anarchist rushed forward and shot the president. Eight days later, McKinley died.

The new president was Theodore Roosevelt, who had gained fame leading the Rough Riders volunteer regiment up San Juan Hill in Cuba during the war and then became governor of New York. Despite eastern roots, Roosevelt saw himself as a westerner from his early years ranching in the Dakotas. He was a fervent conservationist and also committed to the vision of reclamation put forward by Powell and Newell. Both would become hallmarks of Roosevelt's vision of progressivism. Within a year, he signed the Newlands Reclamation Act to fund irrigation projects in the west. The bill's author, Francis Newlands of Nevada, had been a shareholder in the company that built the Arizona Canal.

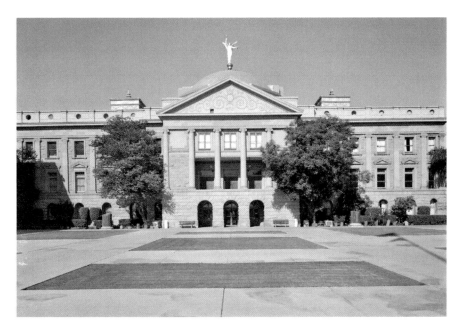

The Arizona State Capitol. The territorial capital had been moved from Prescott to Phoenix in 1889, and this building was opened in 1901. Arizona became a state in 1912. *Library of Congress.*

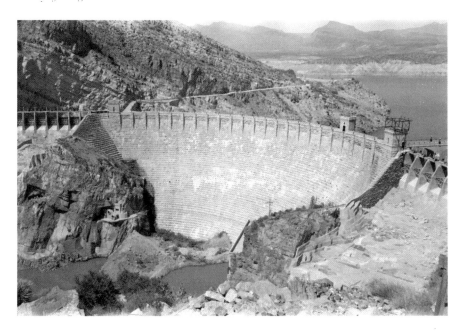

Theodore Roosevelt Dam, completed in 1911, was the first of the dams on the Salt and Verde Rivers that provided Phoenix with reliable water and power. *Russell Lee, Library of Congress.*

When the Theodore Roosevelt Dam was dedicated in 1911, the former president attended the ceremony and pronounced the 357-foot-tall arch gravity structure the most significant achievement of his administration after the building of the Panama Canal. But it almost didn't happen.

When the Newlands Act passed, Arizona remained a territory and the farmers of the Salt River Valley were still paralyzed by infighting, resistance from corporate water interests and mistrust of the federal government. Four other irrigation projects were already in line to be the first funded by Newlands, and others were clamoring to be there, backed by significant political support. Meanwhile, California was about to embark on major water projects for the Imperial Valley and Los Angeles. Their downside risks became famous: a burst canal from the Colorado River turning the Salton Sink into the Salton Sea, and the Los Angeles Aqueduct destroying the Owens Valley. Closer to home, they represented potentially lost market share for Phoenix-grown agriculture products, especially from new farms in the Imperial Valley.

As this reality sank in, on top of the decade of flood and drought, minds changed in Phoenix. Judge Joseph Kibbey drafted a plan that began settling some major water tangles; it led to the founding of the Salt River Valley Water Users' Association (SRVWUA). The association—a collective effort Powell would have applauded—was incorporated in February 1903, and two months later, Interior Secretary Ethan Hitchcock gave his approval. The federal government would build a dam at the Tonto Basin location laid out by the Breakenridge survey. To fund the project bonds, valley farmers mortgaged more than 200,000 acres of their land.

Finally came the landmark 1910 *Hurley v. Abbott* lawsuit, where Judge Edward Kent laid out how water from the Salt and Verde Rivers would be apportioned to the 4,500 landowners made parties to the litigation. The western adage, "Whiskey's for drinkin' and water's for fightin' over" was not completely laid to rest, but the battle within the Salt River Valley was largely settled.

Of all the first Newlands projects, the Salt River dam was by far the most audacious. It required building a road from near Mesa east through mountainous terrain, often barely clinging to the edge of escarpments above the river. The dam's materials and cement had to be quarried and manufactured on site, with much of the work done by hand picks and mules. Apache crews made up the majority of the workers. Heavy rains and another flood pushed back construction timetables. But when it was completed, it was the largest dam in America and for decades was the tallest masonry dam in the world. Behind it, Theodore

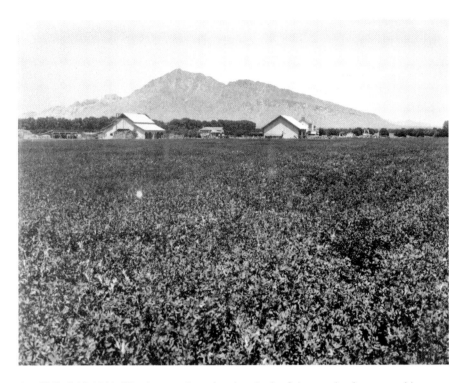

An alfalfa field, 1911. Thanks to reclamation, hundreds of thousands of acres would ultimately be turned into farmland. *Walter J. Lubken, Library of Congress.*

Roosevelt Lake could impound nearly three million acre-feet of water—turning destructive floodwaters into a manageable resource.

Audacious, too, was Phoenix's role in the progressive ideal of reclamation as a tool of social reform and serving the public good. The Newlands Act was the most energetic federal action since the Civil War and provided a template for such New Deal efforts as the Tennessee Valley Authority. Neither Arizona's territorial government nor private companies were given a role in building the great dam and its delivery systems. Instead, it was a federal project, a massive infrastructure investment. Progressives believed it would open the valley to become a "healthy" community of Jeffersonian farmers, with migration taking pressure off the populous, polluted industrial cities of the east and midwest. New farmers in the valley would be limited to 160-acre parcels and speculators were banned from buying irrigated public lands, the better to keep a democratic agrarian society of small family farms. Reclamation in Phoenix was the most widespread experiment of social engineering in American history.

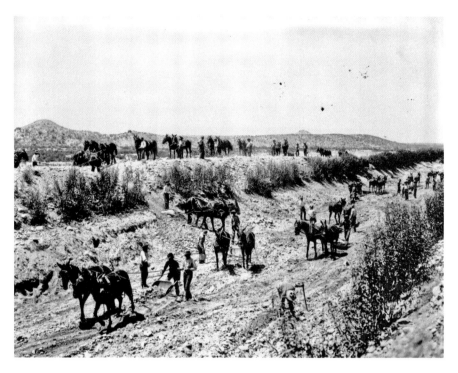

Scraping the Arizona Canal, one of the valley's main arteries for water, 1908. *L.M. Morgan, Library of Congress.*

More dams would follow, part of a vast plumbing system that would eventually reach to the Colorado River. On the Salt, these consisted of the Mormon Flat Dam (1925), the Horse Mesa Dam (1927) and the Stewart Mountain Dam (1930), all between the Roosevelt Dam and Phoenix. The Bartlett Dam controlled the Verde River in 1939, followed by the Horseshoe in 1946. More than 1,300 miles of canals and laterals (smaller irrigation ditches) would lace the Salt River Valley, its arteries carrying water, the lifeblood of the desert. In addition to flood control and water storage and delivery, many of the dams generated hydroelectricity. In 1919, the city of Phoenix signed its first agreement to buy water from the SRVWUA. Although it is unlikely anyone knew it at the time, allowing the new water system to benefit urban areas as well as agriculture would help set the town on the path to becoming a metropolis.

BEYOND STATEHOOD

Dwight Bancroft Heard was born in Massachusetts and moved to Chicago as a young man. There, he married Maie Bartlett. But the couple left when doctors told Dwight he needed to find a place with a dry climate and clean air because of a lung ailment. They chose the capital of Arizona Territory and arrived in 1895. Dwight was born in 1869 and Maie a year earlier. The generation that fought the Civil War settled Phoenix. Now, their children would begin making it more than a small town.

The two would go on to become some of the most consequential civic stewards in the city's history, especially for the Heard Museum, which began with their private collection and is world renowned for its tribal art and Hohokam artifacts. Maie Bartlett Heard became the town's foremost philanthropist. Among her first accomplishments was leading the successful effort to build a Carnegie Library. Later, she donated land that would become the Phoenix Civic Center.

Dwight Heard owned more than seven thousand acres of valley farmland, much of it in South Phoenix. Yet unlike some big landholders, he vigorously supported federal reclamation. Heard backed Theodore Roosevelt politically and shared his vision of conservation and wise use of resources for the public good. And far from encroaching on his entrepreneurial energies, Washington's aid to Phoenix helped make Heard even wealthier. A guaranteed water supply increased the value of all land, as well as making the valley an attractive business proposition. His Bartlett-Heard Land and Cattle Company and investment-banking

businesses prospered, and he became president of the powerful Arizona Cotton Association.

In 1912, when Arizona became the forty-eighth state with Phoenix as its capital, Heard bought the *Arizona Republican*. Although a Republican himself, Heard continued the efforts of the previous owner, railroad and mining executive Frank Murphy, to make it a nonpartisan newspaper with solid journalism. He owned it until his death in 1929 and used the *Republican* (the future *Arizona Republic*) to promote a modern, rising and well-governed city and state. In 1920, he completed the seven-story Heard Building on Center Street (soon to be Central Avenue), the start of a boom of new downtown construction. Maie died in 1951 with the future of the museum as a public trust ensured.

It is difficult to find an achievement in Phoenix in the first decades of the twentieth century that didn't bear the mark of one or both Heards. Dwight Heard was a Chicagoan with business training, but this was not the only or most important way he embodied a new kind of Phoenician. Most of all, he saw the good of the community as essential to the health of his private enterprises. It was a code that would be emulated by future generations of Phoenix business leaders and an essential part of the city's rise.

From Town to Small City

Statehood saw Phoenix's population probably surpass that of Tucson to become the largest city in Arizona. In the 1910 census, the two had been 11,314 and 13,193 respectively. But Phoenix was growing about three times as fast. It had also begun to kick off some of its frontier dust and take the shape of a pleasing small city.

The original half-mile town site was spreading out, but it mostly kept the grid first established with Center and Washington Streets being the starting place for numbering lots. Numbered north–south running streets were placed east of Center and numbered north–south avenues west. (In the grid before 1910, some north–south streets had been named after native tribes, states and other sources.) Named streets ran east to west, with the first seventeen honoring American presidents, including the deplorable James Buchanan. This street grid remains in place throughout most of the metropolitan area in the twenty-first century, with some exceptions such as Mesa, Tempe and Chandler. It didn't take long for newcomers to

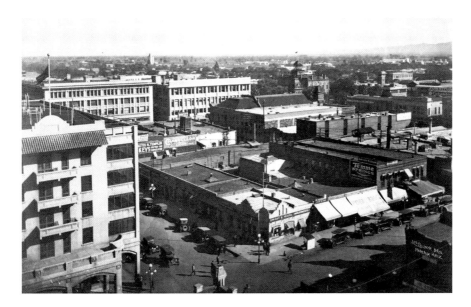

Center and Adams Streets downtown, 1911. At left is the second iteration of the Hotel Adams. *Library of Congress.*

get oriented, not only because of the simplicity of the street grid but also because of the distinct mountains in each direction.

The commercial district fanned out over several blocks from Center and Washington, the stores and offices shielded from the sun by awnings and lit by electric lights at night. Then Washington became a boulevard running past the city hall, county courthouse and Carnegie Library to the capitol building. Handsome Victorian houses also lined this street as well as several others, including "Millionaire's Row" along Monroe Street. North of Van Buren Street, new subdivisions catered to the city's rising middle class and wealthy with bungalows that were well suited to the weather. The early adobe gave way not merely because residents wanted an "American look" to Phoenix but also because adobe bricks often held up poorly to rain. Shade trees and palms, the latter said to have been first imported by Heard, lined nearly every street. Pavement, gutters, storm drains and sidewalks became more ubiquitous.

The city was dense and diverse. It was only a few blocks from Millionaire's Row to Chinatown or the produce district along the railroad tracks. Churches were a few hundred yards from opium dens and houses of gambling and prostitution. Prohibition proved no impediment to getting a drink. More respectable entertainment could be found at the city's growing number of

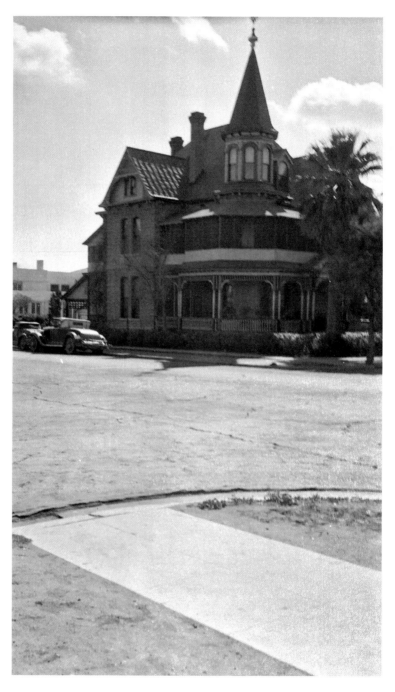

Rosson House, one of many Victorian mansions built in the early twentieth century as the town prospered. *Delos H. Smith, Library of Congress.*

vaudeville and movie theaters, such as the Rialto, Airdrome, Studio or Strand. Many of the movie houses were built and operated by Harry Nace, another health seeker drawn to Phoenix. Phoenicians could eat at restaurants or stop in for "Cactus Candy" treats at Donofrio's, with its impressive neon sign. Travelers could find railroad ticket offices nearby or even in their hotels. Automobiles began to compete with horses and buggies for space on city streets. By 1920, more than thirty garages and service stations operated in town. From the original half-mile site, Phoenix grew to about ten square miles by the end of the 1920s. It was a long way from 1868 and yet in the living memory of many pioneers.

In the years immediately before and after statehood, the city and region embarked on several important public projects. Chief among them was the three-thousand-foot-long Center Street Bridge crossing the Salt River, completed in 1911. Dwight Heard, with his extensive landholdings to the south, led fundraising. Other South Phoenix property owners, who would benefit from easier access to the railroads in town, were assessed a fee and the county contributed money. Former president Theodore Roosevelt rode across the engineering marvel when he visited Phoenix on the way to the dedication of the new dam named in his honor. Phoenix claimed it was the longest reinforced concrete bridge in the world.

In 1912, construction began on new buildings for Phoenix Union High School; it would eventually have one of the largest student bodies in the country. Its Montgomery Stadium, built in the 1920s, would host many important valley events, including the annual Masque of the Yellow Moon celebration. Yet another accomplishment was the Cave Creek Dam in 1923, which stopped the periodic flooding of the fairgrounds, the state capitol and the Santa Fe Railway yards. Not every vision came true. A committee of one hundred citizens drew up an ambitious plan in 1921 for parks and malls that would beautify the city. The proposal went nowhere. The city did create its first planning commission and covered the town ditch to make room for development along Van Buren Street.

When It Sizzled

An inescapable part of the cityscape was the weather: delightful winters but four brutal months of summer heat. When Helen Humphries Seargeant arrived from the east in June, the wall of heat hit her as she stepped off the

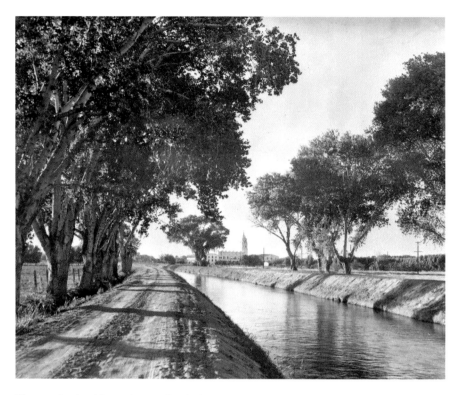

The canals of old Phoenix were lined with cottonwoods and other shade trees. This is the Grand Canal looking toward Brophy Prep, circa 1937. *Library of Congress.*

train. "The sun was exceedingly bright and everything around the station glowed with the heat—even at 8 o'clock in the morning—and I began to be very warm and uncomfortable," she wrote in her memoir *House by the Buckeye Road*. She encountered a local man who shrugged it off. "This ain't hot yet. July an' August—them's the hot months. This is fine weather now. Nights still fine an' cool." Wealthier farmers sent their families to Prescott, nearby Iron Springs or California. The majority toughed it out, using sleeping porches at night, wrapping themselves in wet sheets and running fans for relief. They swam in tree-lined canals and laterals. (Until the advent of DDT, Phoenicians also shook out their shoes in the morning in case a scorpion or black widow spider had crawled inside one overnight.)

It wasn't until the late 1920s that refrigerated air conditioning became a fixture in commercial buildings, especially hotels and movie theaters. Evaporative coolers became available to those who could afford them. Phoenix's major population gains after World War II are often tied to the

coming of affordable air conditioning. But more was at work. For example, in 1920, when Phoenix reached a population of more than 29,000, Dallas had 158,976, Houston 138,276 and New Orleans 387,219. All suffered equally punishing summers, with humidity added to high temperatures; those cities lacked the cool desert summer nights. Phoenix's larger problem: it wasn't a port, major rail hub or the center of the oil industry. Instead, it was situated in an agricultural valley lacking any major manufacturing or even a railroad main line.

The Great War

World War I was mostly far away from the Arizona homefront and noted for producing the Phoenix-born fighter ace Frank Luke Jr. He was awarded the Medal of Honor but died in a plane crash in 1918, only weeks before the armistice, at age twenty-one. However, the conflict did bring one profound change as demand spiked for cotton, specifically the extra-long staple (ELS) variety.

The Salt River Valley was one of the few places in the world where ELS cotton, which was used in tires and other industrial products, thrived. As a result, vast acreage was turned over to cotton growing, and the diversity of Phoenix-area crops diminished. Goodyear Tire and Rubber bought land west of Phoenix and had 1,700 acres of ELS under cultivation by 1917. Valley-wide production jumped to 69,000 acres a year later. The Arizona Egyptian Cotton Company was formed to market the crop.

After the war, demand crashed. Small farmers who had gone all in on the cotton boom were especially vulnerable. This, combined with the national migration off farms and into towns and cities in the 1920s, undercut the federal government's hopes to keep the valley as a model of Jeffersonian yeoman farmers. Families with large farms—such as the Heards, Nortons, Corpsteins and others—added to their holdings, and agriculture increasingly became big business.

The cotton boom attracted large numbers of African Americans to Phoenix. Even before the Great War, cotton interests had been recruiting, promising good wages and better conditions than in the South. For example, Heard hired the Colored American Realty Company to lure black ranch hands and agricultural workers from Oklahoma and Texas. They increased what had been a small African American community that began with Mary

Green in 1868, a domestic servant to former Confederate officer Columbus Grey. Frank Shirley, a barber who arrived in 1887, operated his shop downtown for years next to white businesses. Shirley was a mentor to John E. Lewis, who went on to establish the Lewis Apartments, a hotel catering to black travelers. Also in 1887, an African Methodist Episcopal Church was built. Dr. Winston Hackett, the town's first black physician, arrived in 1916.

The *Phoenix Tribune*, which was published from 1918 to 1931, was the city's major black newspaper. It was not immune to the boosterism of the Anglos, writing in 1919, "Phoenix is the best city in the USA" with "the most friendly relations…between the Caucasians and the Colored people." It admitted, "now and then an antagonistic individual bobs up but the good overwhelms the bad until you scarcely realize any evil has been done."

This even contained some truth when set against the brutality of the Jim Crow South. There was no "colored waiting room" at Union Station, and the Encanto Park golf course accepted minority players. No lynching based solely on race is on record. Chinese American children went to white public schools. But the race and class lines were not hard to find. Phoenix always saw itself as an Anglo city (and the demographics especially after 1920 back this up), unlike old Tucson, with its proud Spanish and Mexican traditions. Phoenix was also a culturally southern city. As a result, segregation against African Americans and Hispanics was widespread, from stores to schools and swimming pools. Arizona maintained an anti-miscegenation law from 1865 to 1962.

Not only blacks but also Hispanics, the largest minority group, were excluded from many opportunities. Asians and American Indians faced similar barriers. Minorities could not buy property north of Van Buren Street. St. Mary's Catholic Church segregated its services, prompting Mexicans to build their own house of worship, the Immaculate Heart of Mary Church, in 1928. Every excluded ethnic group formed its own associations and mutual-aid organizations. In 1926, George Washington Carver High School opened for African Americans; several segregated elementary schools were also built. Nor was discrimination confined to Phoenix. For the first ninety years of its life, Tempe was a "sundown town." Blacks were allowed to work there during the day but had to be gone by nightfall. Some of the greatest hostility was directed to Japanese farmers, especially when they proved more successful than Anglos in some of the more difficult patches of the valley.

Although heavily Anglo, Phoenix was a multi-racial society. It was multiethnic, too. Greeks, for example, ran many restaurants and other businesses. Russian immigrants were recruited to work in the sugar beet fields outside Glendale. Jewish merchants were among the backbone of the

central business district. Najeeb Basha moved from Lebanon, eventually arriving in the valley in 1910, where his family would build a grocery empire.

One last consequence of the Great War appeared symbolic but pleasing. In 1915, even before America entered the conflict, the USS *Arizona* was launched at the New York Navy Yard. Seventy-five thousand people attended the event, including Governor George W.P. Hunt. The length of a sixty-story skyscraper, displacing nearly thirty-thousand tons and bristling with fourteen-inch guns that could throw salvos miles away, the *Arizona* was one of the most modern dreadnaughts in the world. The warship seemed a fitting tribute to a state starting to build its muscles.

REMAKING DOWNTOWN AND BEYOND

As Phoenix entered the Roaring Twenties, the census showed a total population of more than twenty-nine thousand. Anglos composed 87 percent; Mexicans, 8 percent; blacks, 4 percent; and Chinese, less than 1 percent. This decade would see a more dramatic physical transformation, as well as important new transportation links with far-reaching effects.

It was the zenith of American architecture and civic design, epitomized by Art Deco and the City Beautiful movement. A major force behind it in Phoenix was George Luhrs Sr., who emigrated to America from Prussia in 1867 to avoid being drafted into the army and landed in Wickenburg and then Phoenix as a wagon maker at Central and Jefferson. Along with a partner, he bought the nearby Commercial Hotel, changed the name to the Hotel Luhrs and became a prominent business leader and city councilman.

Luhrs developed the old wagon shop site into iconic Phoenix structures. The Beaux-Arts Luhrs Building opened in 1924 at ten stories and hosting the exclusive Arizona Club on the top floor. Across an arcade and also facing Jefferson Street came the Luhrs Tower, fourteen stories high and the city's first Art Deco masterpiece. George Luhrs Jr. led construction of the tower, which opened in 1929.

These were part of a building boom that transformed the face of downtown Phoenix into something substantial and modern. The survivors constitute the best bones of the city in the twenty-first century. Other standouts completed or begun during the decade include the Security Building (1928), the Title and Trust Building (1931) and the Professional Building (1932), as well as two movie palaces, the

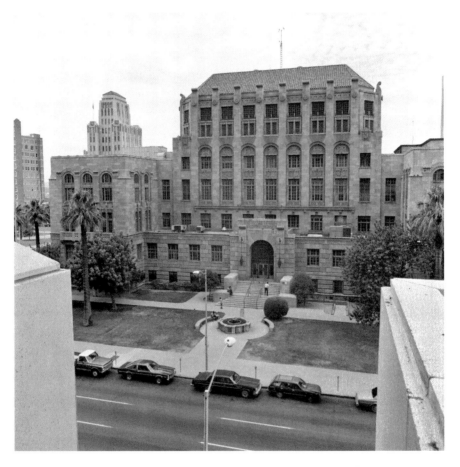

Art Deco Phoenix: the 1929 Maricopa County Courthouse, and to the left is the Luhrs Tower. *Bob Rink, Library of Congress.*

Orpheum (1929) and the ornate Fox Theater (1931), both with refrigerated air. These represented the abundance of speculative capital in the '20s and the small city expanding its base of banking, insurance and professional services as the business center of the entire state. Maricopa County and the City of Phoenix constructed a handsome new combined courthouse and city hall, which melded Art Deco with Spanish influences and opened at the end of the decade. Two fashionable hotels opened in 1928, the San Carlos and the Westward Ho. The sixteen-story Westward Ho would reign as Phoenix's tallest building for thirty years.

Proponents of City Beautiful movement civic design wanted to build a beautiful mall linking the new rail depot with downtown but were

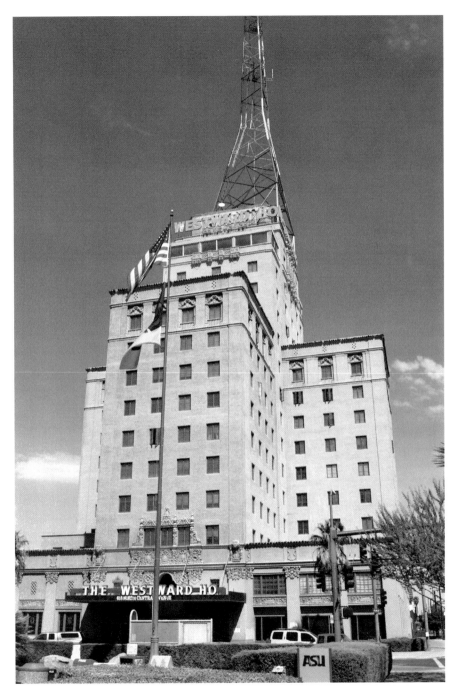

The Hotel Westward Ho, completed in 1928, was Phoenix's tallest building for thirty years. *Kabugenyo, Wikimedia Commons.*

Kenilworth School anchored a neighborhood of high-end bungalows and other houses built in the 1920s. It still stands; this view is from 2012. *Kabugenyo, Wikimedia Commons.*

unsuccessful. They found willing developers, however, in the Portland and Moreland Parkways, shady parks lined with apartments and encircled by narrow roads in the swanky new Kenilworth district built around the imposing new public elementary school of the same name. Two even more upscale subdivisions began farther north, Palmcroft, funded by Dwight Heard and William Hartranft, and adjoining Encanto, developed by Lloyd Lakin and George Peter. These were laid out on City Beautiful principles with shady, winding lanes, pocket parks and period-revival houses.

More residential construction began outside the city limits, especially to the north and east, often separated from the city by farm fields or nestled in citrus groves. North of downtown, Central Avenue quickly became a two-lane street lined by laterals, lush queen palms and haciendas on shady acreages. All around them, the agricultural economy thrived, with 360,000 acres under cultivation.

ARRIVING WITH THE MAIN LINE

Another new building was Union Station, completed in 1923 and jointly owned by the Southern Pacific Railroad and Santa Fe Railway, whose separate wooden stations on Central Avenue were obsolete. The new station, four blocks west and graced with Spanish Mission Revival–style architecture, included indoor and outdoor waiting rooms, a lunch counter, a newsstand, express and mail-sorting facilities and railroad offices. More importantly, the Southern Pacific completed its northern main line through Phoenix three years later.

With through rail service to Southern California as well as Texas and points beyond, Phoenix gained new markets for its produce and the beef being produced from the enormous feedlot and slaughterhouses east of town. Citrus was packed in wooden crates emblazoned with colorful brand names (Miss Phoenix, Big Town, Desert Miracle and Pride of Arizona among them). In the produce district, the crates were loaded into refrigerated

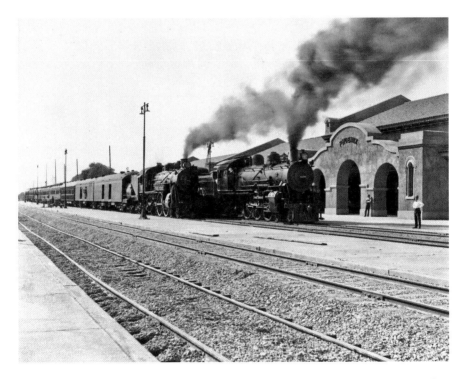

Railroads ended Phoenix's isolation, an accomplishment crowned with the completion of Union Station in 1923. This scene is circa 1945. *McCulloch Brothers Photography, Arizona State University Libraries.*

The Tovrea stockyards, feedlots and slaughterhouses, 1940. *Russell Lee, Library of Congress.*

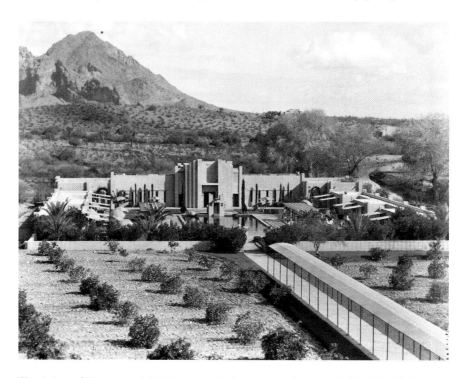

The Arizona Biltmore pool, bathhouse and cabanas soon after completion in 1929. It was the first of the upscale resorts. *Library of Congress.*

boxcars, which were cooled with large ice blocks loaded through the roofs from massive trackside icehouses.

The new mainline—as well as a more direct route from Wickenburg to California on the Santa Fe—was a boon for tourism. The Southern Pacific routed almost all of its passenger trains through Phoenix, including the Sunset Limited and Golden State Limited. The chamber of commerce and the railroads promoted Phoenix as a winter tourist destination, and visitors came from the snowy midwest, often in luxurious sleeping cars. It also turned Phoenix into a getaway for a who's who of Hollywood stars. The Westward Ho and San Carlos competed for celebrity guests—one who stayed in the former was gangster Al Capone. Wealthy tourists came, too, for new luxury resorts that opened, especially the Arizona Biltmore in 1929. For the next four decades, Union Station would be the gateway to the city.

WONDERS AND SIGNS

The decade saw more than new buildings and commerce. Phoenix's isolation was further diminished with the coming of radio. Earl Neilson, who owned a sporting goods store, won an experimental radio license in 1921. A young Barry Goldwater helped around the studio sweeping floors; Goldwater would become a legendary amateur ("ham") radio operator as an adult. The following year, the government granted Neilson a license for a regular commercial station, KFCB (the future KOY). Other stations followed, including KTAR, owned by the largest newspaper and the call letters standing for "Keep Taking the Arizona Republic."

Phoenix Junior College was founded in 1920, providing badly needed post-secondary education for local students. Nearby Tempe had been given a normal school, a teachers' training institution, by the territorial legislature (the University of Arizona had been awarded to Tucson). In 1929, Tempe Normal was renamed Arizona State Teachers College, beginning on the road to becoming a university.

The Phoenix Jaycees Rodeo of Rodeos began in the late twenties. For decades, it would be one of Phoenix's biggest events, with top rodeo riders, a school holiday, parade and "vigilantes" temporarily jailing dudes who dared not to be attired in western wear. By the fifties, the parade would draw as many as 300,000 spectators and include such stars as Marilyn Monroe, Bing Crosby and Bob Hope. The Riverside Park beside the Salt sported a

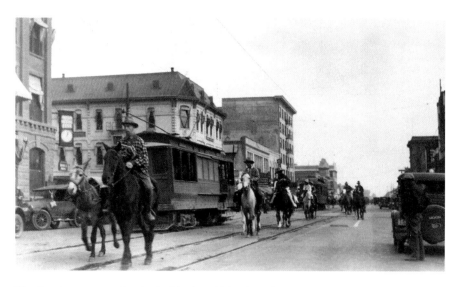

The frontier meets modernity in this circa-1930 view of streetcars and a rodeo parade downtown. *Collection of Jeremy Rowe Vintage Photography; Vintagephoto.com.*

swimming pool and a place for picnickers in a meadow under cottonwood trees, as well as the Riverside Ballroom, which saw most of the jazz greats until it was destroyed by fire in 1957. In a tantalizing hint of the future, the Detroit Tigers played one season of spring training in 1929.

In a far-sighted move, Phoenix acquired the South Mountains from the federal government in 1930; the land would become the world's largest municipal park. More disappointing was the Papago-Saguaro National Monument, created in 1914 by President Woodrow Wilson (then Representative Carl Hayden had wanted a national park). The land had originally been intended to be part of a Pima-Maricopa reservation but was sliced out of the tribal allotment in the late nineteenth century. East of Phoenix and north of Tempe, it contained hilly, saguaro-studded desert land rising up to surreal red buttes. But federal money for upkeep was minimal, and the site fell into such disrepair that Washington took away the monument designation in 1930. It was sliced up among Tempe, the Water Users' Association, the state and Phoenix. McDowell Road was run between the Papago Buttes, and part of the former national monument was taken as a military reservation. Later, architect Frank Lloyd Wright, who had established his Taliesin West in the desert north of Scottsdale, proposed a design for a new state capitol there. The proposal went nowhere. While Papago Park eventually became a local

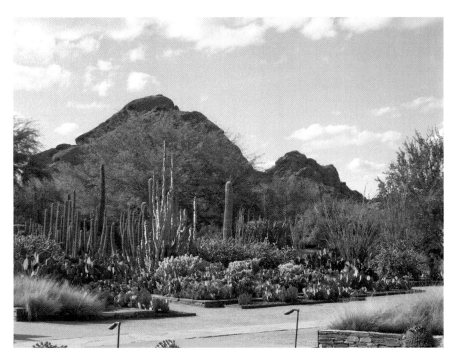

The Desert Botanical Garden in 2012. The garden was begun as a preservation effort in the 1930s. *Wikimedia Commons.*

treasure, it was not what it could have been in one piece, preserved. It represented a recurring theme in Phoenix's future: lost opportunities and attempts to recover from them.

Still, a new skyline, better railroad connections, the magic of radio and more—by the end of the twenties, Phoenix's population grew nearly 157 percent to more than 48,000. City leaders started imagining what seemed unlikely at the time: that Phoenix would overtake El Paso (population 102,451) as the leading city of the Southwest.

PHOENIX IN THE DEPRESSION

Those ambitions, like so many others worldwide, were forced on hold by the Great Depression. Today, it's often stated that the calamity barely broke Phoenix's stride. One writer points to how the local newspapers paid little attention to the 1929 market crash. Most Phoenicians, like most Americans, didn't own stocks. Yet the hard times soon arrived, and the ways the Depression and New Deal affected Phoenix were intense and far-reaching.

After the market crisis, the U.S. economy entered a severe contraction in 1930, and conditions kept getting worse. They knew no state or city boundaries. Demand collapsed for Arizona copper, cotton, cattle and citrus. In Phoenix, two of the city's six banks, along with two of five building and loan associations, failed. Depositors were wiped out. Valley Bank and Trust came close to the same fate. Twelve theaters closed in town. Statewide, the population actually declined in the early thirties.

The relative weight that should be assigned to the many causes of the Great Depression is still being assessed and debated. Both Herbert Hoover and John Maynard Keynes traced it to the financial imbalances and distortions left by the Great War and the harsh Treaty of Versailles. Additional factors include the self-defeating orthodoxy of the day that demanded balanced budgets and the gold standard, Federal Reserve policy missteps, a rickety banking system, the environmental disaster of the Dust Bowl, the Smoot-Hawley tariff increase and the huge speculative bubble created in the laissez-faire twenties.

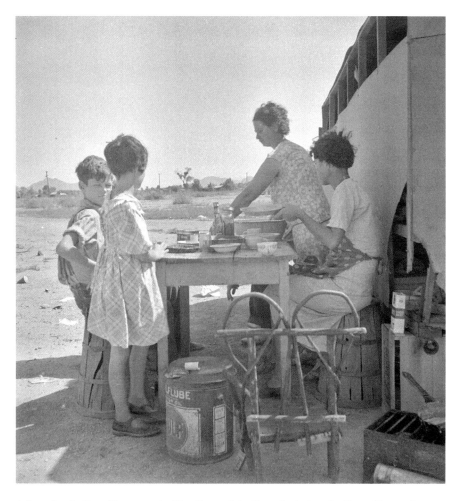

A farm family from Tennessee looking for work in Phoenix during the Great Depression, 1936. *Dorothea Lange, Library of Congress.*

The boom also cloaked profound shifts in the farm economy caused by mechanization, overproduction and excessive debt. Banks in farming regions failed all through the twenties. It appears that the valley was largely insulated from the worst of these problems after pain of the 1919 cotton collapse subsided. But it's intriguing to ask whether federal reclamation policy played a role? After all, the national government subsidized new competition for American farmers in central Arizona and other "reclaimed" areas. And the valley's soil was capable of some of the highest yields of the day.

Whatever the causes, the result was the greatest crisis the nation faced since the Civil War.

The Crisis Comes Home

Arizona first felt the economic contraction that would lead to the Depression with the plunge in copper prices, devastating the state's largest industry. Mines closed, some permanently. Some towns never came back, at least as mining districts (Jerome among them). Even better capitalized operators, such as Phelps Dodge, laid off large numbers of miners. It is difficult for today's Arizonans to understand how important mining was to the state then; the collapse of copper prices was at least as big or bigger a disaster as the 2008 housing bust—but no safety net existed in 1930.

Many unemployed mineworkers and their families came to Phoenix. They were joined by a segment of the population of the southern plains fleeing the Dust Bowl, as well as migrants from farther east, as farms were seized and farm and industrial jobs went away. Highways and railroads had evolved enough to make Phoenix easier to reach. Some of the Okies, Texans and Arkansans had relatives there; most only hoped for a new chance.

Unfortunately for them, all commodity prices—including cotton and citrus—tumbled as contraction became depression and deflation set in. From

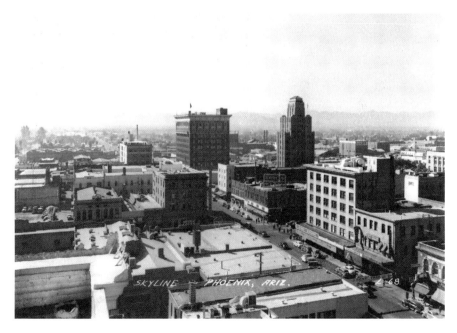

The Phoenix skyline in 1930 looking toward the warehouse district and South Mountains. The two tallest buildings are the Luhrs Building, center, and the Luhrs Tower, right. *Brad Hall Art.*

1930 through 1933, hardship, desperation and fear played out in Phoenix in much the same way as in all of America. Even those who had jobs worried they would lose them as businesses closed around town. Relief organizations were overwhelmed. Shop owners were forced to cut off credit to longtime customers in a bid to survive. "Hoovervilles," makeshift camps of tents and shacks, appeared in and around the city (a notable one was in the separate, unincorporated settlement of Sunnyslope, north of Phoenix).

Among the big local business casualties was the Agua Fria River Project west of Phoenix, which had been private effort since the 1880s to dam that river and reclaim land just east of the White Tank Mountains. Waddell Dam, or Frog Tanks Dam, was finally completed in 1927 under the supervision of engineer Carl Pleasant. But the vision of a rival to federal reclamation, probably never realistic in the best of times, died as the economy declined.

Phoenix's New Deal

For the second time in its young life, Phoenix was rescued by the federal government—another Roosevelt, too. In the 1932 presidential election, Arizona voted overwhelmingly for Franklin Delano Roosevelt, who had campaigned in Phoenix with Senator Carl Hayden and Governor George W.P. Hunt. Most Phoenicians were too close in time to the fruits of the Newlands Act to have any "rugged individualist" illusions. They knew that without the federal assistance at the turn of the century, Phoenix might have died.

It proved a good bet. When FDR became president in March 1933, the nation began a long but very real turnaround. Unlike the tragic Hoover, Roosevelt was insistent on using the power and resources of the federal government to help individuals. Critical to his success, he was willing to experiment. The New Deal worked out exceptionally well in Phoenix. One reason may have been the size of the place in relation to the aid received. The historian Lawrence Arlington calculated that Arizona received $342 million in federal aid from 1933 to 1939—about $5.8 billion in today's dollars—and paid only $16 million in federal taxes. Large sums went to projects in Phoenix that created jobs and built infrastructure.

Assistance from Washington came in many forms, including the Works Progress Administration (WPA); the Bureau of Public Roads; the Public Works Administration (PWA); the Civilian Conservation Corps (CCC), which had three camps around Phoenix; and assorted farm aid and

agricultural price stabilization programs. Together, these groups employed thousands and became huge drivers of recovery. Del Webb, a builder who arrived in Phoenix in the late twenties and was a big FDR supporter, made his early wealth thanks to New Deal contracts.

By 1935, the federal government was the county's largest employer and buyer of goods and services. Among the major CCC projects were building improvements to South Mountain Park and the new Papago Park. New Deal money helped Phoenix acquire the land for Encanto Park, its most beautiful city park, and erect some of its enduring buildings (and some that didn't last, notably the bandshell). Eastlake Park and Grant Park were two other New Deal gifts. Encanto, especially, was a gem for a city that had entered the decade with only seven shabby parks.

North High, the city's second high school, was built in 1938, followed a year later by a dedicated campus for Phoenix Junior College. The WPA also built the stadium at the state fairgrounds and the state capitol annex with Jay Datus painting the murals *The Pageant of Arizona Progress*. The PWA built Glendale's water system.

Federal funds helped the city acquire land for Sky Harbor Airport, and the WPA paved its runways and aprons, as well as built its first terminal and administration building. The Spanish Colonial Revival U.S. post office

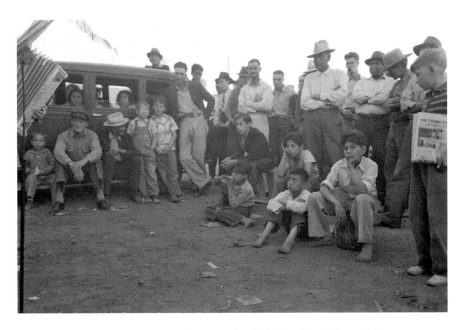

A crowd listens to an orchestra outside a store in 1940. *Russell Lee, Library of Congress.*

and federal building was constructed in 1936 at Central and Fillmore. La Verne Nelson Black and Oscar Berninghaus painted murals in the lobby. (The project actually began under Hoover, but the plaque credits Roosevelt and his postmaster general—and political fixer—James Farley.)

Infrastructure building didn't stop with roads, parks, the airport and schools. During the 1930s, the Bartlett Dam was built on the Verde River. CCC crews completed more than seven hundred separate jobs for the Salt River Project, the public entity that administers water for the Salt River Valley Water Users' Association, as well as power. All these New Deal undertakings put thousands of people to work and left enduring buildings, roads, dams, parks and the airport.

The non-farm private sector began a slow recovery, too. It helped that Phoenix had already attracted some wealthy patrons, such as the chewing-gum mogul who built the Wrigley Mansion. Many wealthy Americans benefited from the New Deal even as they called Roosevelt "a traitor to his class." They vacationed in Phoenix with money to spend. The chamber of commerce unveiled a campaign using the term "Valley of the Sun," and it was a big success.

So-called health seekers also continued coming. One was John C. Lincoln, the founder of Lincoln Electric in Cleveland, who arrived in 1931 when his wife, Helen, was diagnosed with tuberculosis. He returned regularly and invested in copper mines and land. He also added to the luxury resort business with the Camelback Inn, located in the desert between Camelback and Mummy Mountains. It opened in 1936. Lincoln became best known for his patronage of the Desert Mission, which provided aid to Sunnyslope residents. It became the John C. Lincoln Hospital.

Fighting for its life, Valley Bank hired Walter Bimson to be its president. Bimson would go on to become one of the most consequential business statesmen in the city's history. But immediately, he went about repairing the bank. Having worked in Hoover's Reconstruction Finance Corporation, Bimson had no hesitation about accepting federal help. He famously told his officers to make loans. Less well known is that he leveraged New Deal financial programs to help. Valley National became the biggest bank and most powerful corporation in the state.

Local manufacturing received a boost as the technology became available to provide air conditioning at an affordable price for houses, with the evaporative cooler. The first major breakthrough in allowing Phoenix to be habitable year-round by large numbers of people was made locally and sold widely.

PUSHED BETWEEN THE CRACKS

Some experiments were embraced more than others. The Farm Security Administration established cooperatives such as Camelback Farms to aid displaced farm families. The Subsistence Homestead Division of the Interior Department had its own plans for "urban farming" by the poor on small plots of land. One result was Phoenix Homesteads. These projects brought out the "deserving" versus "undeserving" poor debate, with many Phoenicians worried they were drawing undesirable elements. Such efforts gave ammunition to critics who claimed that the New Deal was socialism and considered Roosevelt—"that man in the White House," they couldn't stand to say his name—a dictator. But like the genuinely socialistic Casa Grande Valley Farms, a project of the Federal Resettlement Administration and run by Walter Packard, they gave temporary relief but failed in the long run.

Even as the New Deal built infrastructure, aided farm prices and put people to work, class and ethnic resentments flared. The former were at work in resistance to such endeavors as the Phoenix Homesteads. The animosity also galvanized the Associated Farmers of Arizona, formed by wealthy landowner (and liquor baron) Kemper Marley. The organization's

Camelback Farms of the Farm Security Administration, one of the New Deal programs to help migrants during the Depression. *Russell Lee, Library of Congress.*

goal was to stamp out the "communism" represented by farm workers complaining about the dismal and unsanitary growers camps and an effort by the Congress of Industrial Organizations (CIO) to organize them. Marley's men succeeded.

Anglos who formed the Anti-Alien Association attacked and made threats against Japanese farmers. This criminal activity eased when the state Supreme Court struck down the 1921 Alien Land Law that targeted the Japanese and "respectable" leaders such as Governor Benjamin Moeur intervened. But the soil had been tilled for the later Japanese internment during World War II.

Thanks to the success in agricultural price stabilization, cotton rebounded and demand grew as the world militarized in the later years of the decade. This also created a large demand for workers; mechanization had yet to reach most Arizona cotton fields. Yet quarters were segregated, and pay was lower for minorities. Historians generally argue that the New Deal was disappointing in its achievements for minorities compared with Anglo citizens.

The administration did include the slum southwest of downtown Phoenix in a nationwide study, finding it to be the worst in America. This was where Catholic priest Emmett McLoughlin was sent after being ordained in 1933.

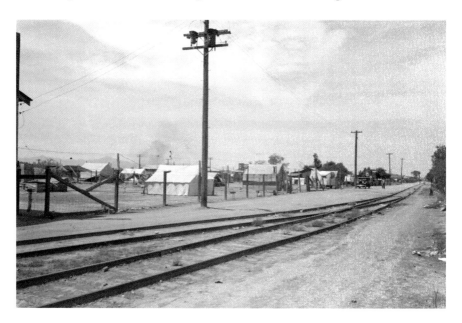

Housing shortages and slums plagued Phoenix as it grew. This photo is from 1940. *Russell Lee, Library of Congress.*

He became an indefatigable advocate for the poor and a scourge of the city fathers. The slum, he said, was "a cesspool of poverty and disease." He was named the first chairman of the federally funded Phoenix Housing Authority. Much of the slum was cleared for the Matthew Henson projects for blacks. The Marcos de Niza projects were built for Mexican Americans and the Frank Luke projects for Anglos.

McLoughlin never became reconciled to Phoenix's maltreatment of the poor and marginalized, saying they were regarded as "rejects of a lusty, sprawling, boasting cotton-and-cow town trying hard to become a city…veneering itself with the gloss of a symphony orchestra, a little theater and a necklace of resort hotels."

BEYOND HARD TIMES

Life went on in the Depression years and for Phoenix in a spectacularly lurid way with the Trunk Murderess. Winnie Ruth Judd, a medical secretary, was accused of murdering two women, allegedly out of jealousy over a man in 1931. Dismembered bodies, romantic intrigue, escape to Los Angeles aboard a train, the infamous trunks leaking blood and a seeming femme fatale from pulp fiction—the story riveted the nation. The journalist Jana Bommersbach has made a convincing case that powerful Phoenicians railroaded Judd, which would not be the last time justice was bought and miscarried in Phoenix.

The city also had plenty of straightforward lawlessness. Some of it involved the prostitution and gambling that would plague Phoenix for years. Other incidents seemed to come out of a much bigger city. For example, on the night of May 19, 1936, two burglars coming out of Arnold's Pickle Company on Van Buren Street got the drop on two police officers arriving in the eastside radio car (Phoenix police had installed the state's first police radio system in 1932). Another officer, Earl O'Clair, drove up. One burglar fled, but the other threatened to kill one of the cops he held hostage. When O'Clair refused to give up his sidearm, a last-man-standing shootout ensued. The burglar's .45 jammed when he tried to shoot the hostage. O'Clair shot twice. The suspect returned fire with a .38 he stole from the cops, peppering the police cars. The battle continued down the alley and as far as Monroe Street, a block away, before the burglar fell dead. O'Clair, who went on to become chief, fired six shots and hit six times. Even then, Phoenix could be a dangerous town.

Hollywood continued making distractions, which seemed even more important in such dark times. Mae West even visited the Orpheum in 1933. The legislature still met informally in the coffee shop of the Hotel Adams, as it had before and would continue to do into the 1960s.

The ruin suffered by even wealthy farmers and the loss of the tax base put most civic projects not funded by the New Deal on hold, but not all. The Desert Botanical Garden opened in 1939 in Papago Park, led by botanist Gustaf Starck and wealthy patron Gertrude Webster. It would become one of the city's most visited spots. Another step forward was the Phoenix Open golf tournament, started in 1932 and then stopped but revived in 1938.

For Phoenix, as for most subjects, history is not neatly sliced into decades. Larger economic, social and demographic forces blend the years together. Perhaps the closest we come is the thirties. Its dominant event affected nearly everything and everyone. And although it had been almost overwhelmed with the scale of the disaster early on, Phoenix emerged stronger. By 1940, Phoenix had 1,207 retail stores with sales close to $48 million ($818 million in 2015 dollars). The city's wholesalers numbered more than 190 establishments employing more than two thousand and handling everything from farm products to liquor, lumber, tobacco, electrical goods and groceries. By comparison, Tucson had

Central Avenue and Washington Street, in the heart of the city's retail district, 1940. *Russell Lee, Library of Congress.*

63 wholesale establishments. Manufacturing was mostly small and local, but still important. According to the census, Phoenix had eighty manufacturing establishments in 1939. Foremost among them were the Tovrea Packing Company, Arizona Flour Mills, Holsom Bakery, Allison Steel and Western Pipe and Steel, as well as brick and tile makers and icemakers. In addition, the value of building permits rebounded from $46,050 in 1933 to $1.7 million in 1940. The city seemed poised to resume its rise.

WARTIME

A visitor to Phoenix today can find the anchor to the battleship *Arizona* as the centerpiece of a park on the Capitol Mall west of downtown. It is a visceral reminder of how people in the forty-eighth state felt personally assaulted on December 7, 1941, when the Japanese Imperial Navy attacked the Pacific Fleet at Pearl Harbor. On Battleship Row, the *Arizona* took a direct hit to its forward magazine. The explosion killed 1,177 crew members. Vivid photographs of the dying ship became synonymous with the Day of Infamy. After Congress declared war on Japan, Adolf Hitler supported his ally and did the same against the United States, sealing his doom. But a reeling America faced nearly four years of battle before the Axis was defeated. Once again, Phoenix produced a Medal of Honor winner, Silvestre Herrera.

War had been going on since China began resisting Japan's aggression in 1937, more than two years before Hitler's legions attacked Poland. Salt River Valley farmers benefited from rising prices, especially for cotton, as the world began rearming in the mid-thirties. Demand rose further as President Roosevelt coaxed a Congress with a strong isolationist bent into agreeing to expand America's small military in the name of "preparedness." Once again, the need exploded for extra-long staple cotton. Interestingly, FDR's economic sanctions on Japan because of its aggression against China extended to scrap and oil but apparently never to cotton. In any event, there was no shortage of buyers, internationally or domestically. As factories recovered from the Depression (and a nasty 1937 recession when FDR

backed off the New Deal) and received new orders for armaments, more Americans went back to work. This brought back more customers for the other agricultural bounties of the valley.

Bases and Industry

Even before Pearl Harbor, the growing army air forces began scouting locations for pilot-training bases as part of Roosevelt's preparedness campaign. Phoenix's nearly three hundred sunny days a year made it a natural choice. In the spring of 1941, Thunderbird Field opened near Glendale to train American, Chinese and British pilots. Falcon Field east of Mesa began operations in September. More training fields would follow, including the large installations Luke Field and Williams Field. In addition, the army established a desert-warfare training center west of the city; for a time, General George Patton led exercises there.

One future pilot was Lincoln Ragsdale from Ardmore, Oklahoma. But because the armed forces were segregated and Ragsdale was an African American, he completed his initial training in Alabama, becoming one of the famed Tuskegee Airmen. While there, he was pulled over and beaten by police for not showing proper deference to a white gas-station attendant. He was transferred to Luke Army Airfield for gunnery training, becoming one of the first African American pilots there. Later, he would comment about how Phoenix's racial attitudes were similar to what he had encountered in the Deep South. But he also saw promise in the oasis city.

In some cases, such as Luke, the city of Phoenix bought land for the base and leased it to the federal government. The Phoenix Chamber of Commerce mounted a lobbying campaign with the War Department. Patriotism and desire to do one's part were at work, but so was the desire to grow Phoenix's economy. The city's population was 65,414 in the 1940 census; Maricopa County's stood at 186,193. But the regional economy was still mostly agriculture, along with smaller local manufacturing and being the commercial and banking center of the state. It was not enough if Phoenix were to take its place alongside leading western cities.

Washington's desire to decentralize industry and move some critical wartime production away from the coasts helped. Goodyear Aircraft, AiResearch and Alcoa were among the largest companies to arrive, bringing the first large factories seen in the valley. Historian William S. Collins reports

that the war brought $47 million in new industrial operations, along with $90 million in contracts to build bases and other war-related facilities. Del Webb, who already had the largest construction company in the Southwest thanks to the New Deal, was a prime beneficiary.

The valley's farms struggled with a labor shortage as Allied demand for food and cotton soared. Part of this was of the Anglos own making. Through most of Arizona's history, the border with Mexico had been open and porous; people came and went easily. But the federal government deported half a million Mexicans during the Depression, and local Anglo antipathy toward Hispanics, which was a recurring theme in Arizona history, became extreme. Mexican Americans, like all minorities, rushed to the colors after Pearl Harbor, and many left for military service. This worsened the labor problem because they worked jobs from fieldwork to packing and loading in the produce district. Washington responded by negotiating the bracero program with Mexico City, with thousands of skilled and unskilled Mexican workers returning to the United States for work.

The braceros also helped with railroad track work. America's railroads were taxed to the breaking point during the war moving military personnel, raw materials and military hardware. By 1944, more than 3,500 freight cars were flowing every day into California, many coming on the railroads through Arizona. Women took many of the station agent, telegrapher and

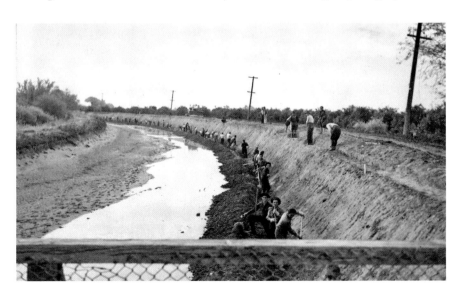

Italian prisoners of war working on maintenance of the Arizona Canal, December 1943. *Library of Congress.*

dispatcher jobs that had been held by men. Union Station was a very busy place as dozens of trains either arrived carrying new airmen or passed through filled with soldiers, marines and sailors. Civilians were packed onto trains as space allowed.

Another sign of the war was the German and Italian prisoners of war (POW), many housed at a POW camp in Papago Park. Some worked on local projects, such as dredging and maintenance of the canals. In December 1944, twenty-five Germans tunneled out. While the escape caused a brief sensation, most of the POWs didn't get far in the cold desert. U-boat commander Jurgen Wattenberg, who masterminded the plan, held out more than a month. His luck ran out when he went downtown and asked for directions in a German accent.

Phoenix Vice

As thousands of soldiers and civilian workers flooded into the city, they found a place both enchanting and yet also darker than the Eden of the "Valley of the Sun" tourism marketing. Beneath its lovely setting and Art Deco skyline, Phoenix was a wide-open western town. Gambling, prostitution and saloons flourished in the Deuce (theories of the name's origin are that it flowed out of the pro*duce* district and was Beat Two for the Phoenix police), the city's skid row that ran along Second Street. The Deuce also contained the infamous Paris Alley just south of Jefferson Street, a dense hotspot of vice and violence. This intersected with "Red Light Row," which ran east to Sixteenth Street. Among its houses of ill repute were Irene's, Mark's Place, the Cozy Room and the Dunbar.

These establishments operated with more than the averted eye of city government. Fees from prostitutes and owners of red-light establishments helped fund the city treasury. At the same time, officials imposed an unwritten rule that required prostitutes to get twice-monthly physicals. These attempts at controlling vice were only partly successful with the influx of military personnel and call girls. In some cases, detectives still took bribes to provide protection to the whorehouses and gambling spots. At least one city commissioner (city council member) was rumored to be a partner in prostitution operations. Organized crime was gaining a foothold in the fast-changing city.

Military commanders were not satisfied either. Citing rising venereal disease, they declared the city off limits to base personnel in November 1942.

It was the same month that American soldiers were invading North Africa and five months after the navy had turned the tide against the Japanese at the Battle of Midway. Phoenix's business leaders immediately realized this would be a catastrophe, not only for retail sales in the Christmas season but also for the city's reputation, for its hopes to attract more military installations and industry. Lawyer Frank Snell, the most formidable member of the business elite, organized what became known as the "card room putsch," demanding that the city commission fire the city manager, police chief and city magistrate. The ban was soon lifted, but commissioners quickly reneged on the deal. This led businessmen and the chamber of commerce to create the Phoenix Citizens Good Government Council, which successfully elected two new commissioners. It was the first step in the years-long battle to control city hall.

Race and the Homefront

On February 19, 1942, as salvage operations continued on Battleship Row and the United States forces were being routed in the Philippines, President Roosevelt signed Executive Order 9066. It provided for the forced relocation of Japanese, including American citizens, from "military areas" in the United States to be designated by commanders. More than 110,000 were interned in concentration camps, although no evidence ever emerged of Japanese espionage or a "fifth column." (By contrast, only 7,000 German Americans and 3,000 Italian Americans were interned.) Curiously, none of the Japanese were removed from Hawaii. But the large West Coast "exclusion zone" literally ran through the heart of the Salt River Valley.

Japanese and Japanese Americans living north of U.S. Highway 60—Grand Avenue and Van Buren Street in Phoenix—could remain. But those to the south, including the farmers who had been so successful along Baseline Road in South Phoenix, were sent to camps. Two of the largest were in Arizona, Poston and Gila River, both erected by the premier builder Del Webb.

The internment is now considered one of the more shameful chapters in American history. At the time, even Eleanor Roosevelt thought it was regrettable but necessary. After the shock of Pearl Harbor, many feared an attack on the mainland. Some (now obviously) fanciful Japanese war plans called for forcing America to hand over the states west of the Rockies as part

of its surrender. But some scores were also being settled, in both California and Arizona. Since their arrival in small numbers earlier in the century, the Japanese had faced enormous hostility from many valley residents. That they prospered on land that had bedeviled Anglo farmers made the racial antagonism even more pronounced. Arizona's Alien Land Act had been specifically aimed at the Japanese, although many continued to hold land and farm thanks to help from sympathetic Anglo neighbors. The legislation was so egregious that Japanese diplomats protested to Washington but to no avail. For the Anglo antagonists, internment was a welcome, even overdue, policy. The Japanese could only hope that they could reclaim their land when the war ended. In Phoenix, Chinese wore badges stating their ethnicity and that their mother country was an ally and not an enemy.

Inside the camps, internees put out newspapers, played baseball and tried to make a home. Many young men volunteered for the U.S. Army despite the internment. The Japanese American 442nd Regimental Combat Team fought in Europe and became the most decorated unit of its size in the army. Small numbers of Japanese American women were allowed to transfer to sympathetic eastern colleges. But most internees were kept for years, until the program came under increasing criticism. One of the biggest critics was Eleanor Roosevelt, who visited the Gila River Internment Camp south of Phoenix in 1943 and came to believe her husband's executive order was a great evil.

Racial troubles continued in town as well, notably in a 1942 event known as the Thanksgiving Day Riot or the Phoenix Massacre. It began when an off-duty black soldier struck a black woman with a bottle in a café. A black military policeman (MP) attempted to arrest the soldier when he allegedly pulled a knife; in response, another MP shot and wounded the man. Around 150 black troops in the area saw buses arrive to take them into custody. Most had nothing to do with the incident in the café, but they were placed under arrest when a Jeep full of armed black soldiers pulled up, insisting their comrades be freed.

As tensions grew and a crowd gathered, someone fired a shot. More bullets flew, and a riot was under way. In another telling of the story, angry soldiers from the segregated 364th Infantry Regiment returned to camp and armed themselves and then went back to Phoenix to stand their ground in an all-night gunfight. Others soldiers hid in black homes. MPs and Phoenix police officers embarked on an intense search for the perpetrators in the city's black neighborhoods. The search included soldiers in halftracks firing .50-caliber machine guns through the paper-thin walls of houses. While details of the incident are still being debated, at least three died and eleven were wounded.

Phoenix was not alone in such homefront violence. Thirty-four died in the Detroit race riots of 1943. But the violence was contrary to Anglo Phoenix's rising self-image as a progressive city that had left behind the troubles, grudges and feuds that beset older places. Even then, Phoenicians had a thin skin about criticism and how the nation perceived the city. The Thanksgiving Day Riot doesn't appear to have received much press outside of black newspapers, and it faded, or was pushed, from local memory within a few years.

The Housing Crisis

Newcomers also encountered a problem that the New Deal didn't address. Although new subdivisions had been extensively platted during the twenties, almost no new houses or apartments were built during the Depression. As a result, the city faced a serious shortage of housing. People were encouraged to take boarders as a wartime sacrifice. Some people lived in tents. Outside the city limits, even housing constructed before the Depression varied widely in condition. Many houses depended on septic tanks; some used outhouses. Most of the residences were dependent on private water companies, while a few had no plumbing at all, with residents forced to haul water in milk or jerry cans. Transient camps reappeared, including the notorious "Stinking Acres" near Fortieth Street and the Grand Canal.

It would take years for Phoenix to catch up. In the near term, construction labor wasn't available with so many men serving in the armed forces, nor were materials available with the economy focused on war production. Very little new residential construction, even for workers in the new war factories, happened during the war. And almost all of these houses were of inferior quality. In addition, pre-Depression house building tended to be on a small scale, sometimes one house at a time. The results were often superior craftsmanship and lasting quality. But it was not an arrangement that lent itself to producing large numbers of houses quickly. Levittown, the first mass-produced housing development, didn't open on Long Island, New York, until 1947. In Phoenix, residential construction lost more than fifteen years by the time the war ended. Some of the old builders and real-estate professionals had moved on to other jobs, retired or died. The wound was also partly self-inflicted. Because of the city's failure to plan for growth and debates tinged with both racism

and class antagonism, Phoenix had refused most federal housing money during the thirties.

The housing crisis and the other stresses of the war raised more fundamental issues about the future, especially as victory became inevitable and approached sooner than many had expected. Was the city's leadership up to the challenges of such fast growth, which might accelerate after the conflict's end? Would the old ways of doing things suffice, or were major changes needed? Could the city hold onto its wartime economic gains and expand them? Was the political system sufficiently responsive and ethical—and who would wield power at city hall, business, labor or other interests? Most of all, what kind of city would Phoenix become, for the compact prewar town surrounded by groves and fields had already been disrupted by defense plants built far from the urban footprint. Then there were questions that weren't even asked by the Anglo majority, chiefly about the rights and treatment that minority soldiers would expect when they returned from distant battlefields.

Phoenix would spend years sorting this out, and the answers wouldn't come without a fight.

BUCKLE OF THE SUNBELT

The popular history of postwar Phoenix is that it began an unbroken trajectory of explosive growth and never looked back. GIs who trained there or passed through liked what they saw and wanted to move back as civilians. Aided by the miracle of affordable air conditioning, they were able to do just that and in huge numbers. In the process, Phoenix came to emblemize the migration to the Sunbelt that has continued for seventy years. But this generalization can miss nuances and shadings, larger forces and important local peculiarities. Even if it isn't exactly wrong, such a neat narrative can distort and mislead.

In fact, Phoenix on V-J Day was critically unprepared for the future. In addition to the housing shortage discussed in the previous chapter, streets were in disrepair, retailers had been unable to invest in their downtown stores and investments in everything from streetlights to transit had not been made. Leaders had a sense that the city would grow in peacetime, but there was no blueprint to provide services and planning for it. Traffic was a mess, and downtown parking lacking. In addition, while cities such as San Diego worked hard to retain industry and lure new companies, Phoenix was sandbagged as contracts dried up and almost all war factories closed. The valley was especially hard hit by the 1945 recession as government spending declined. Things were little better in the downturn that began in 1948. Many people worried that the country would fall back into a depression.

As Phoenicians struggled with the transition, a political battle long in the making was joined in the latter years of the forties.

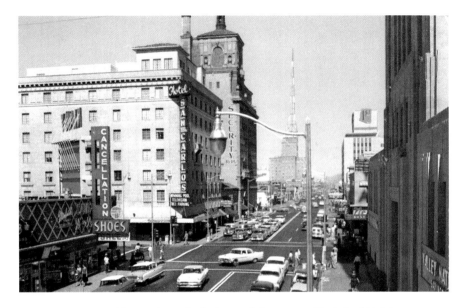

Central Avenue and Monroe Street in the heart of downtown, 1956. *Brad Hall Art.*

Remaking City Hall

Phoenix had adopted the city manager form of government years earlier. In reality, the position was weak and turnover was frequent. Elected leaders held real power, and the ability to get things done—or not. They sat on a four-member city commission led by a mayor. In one of many southern-flavored elements that remained in the city, sometimes each commissioner oversaw specific city departments.

Even the basics of municipal work were highly politicized. Officials came and went and sometimes returned. Commissioners were defeated by an effervescence of "reform" and then elected again two or four years later. Efforts to piecemeal change the city charter failed. This whirligig made for instability at city departments; services suffered and hapless city managers were sacked with disturbing regularity. Thus, the rising field of professional city management was kept from penetrating the fortress guarded by the carved stone Phoenix birds at the entrance to city hall.

Just how corrupt this system was remains a subject of debate. History is written by the victors, and they had an interest in presenting the city commission in the worst possible light.

Organized crime was indeed growing in Phoenix, first with liquor distribution and bookmaking and then with the city acting as a back office

for Las Vegas. Gus Greenbaum and his brother Sam were bookies with mob connections to Vegas. Another gangster, Roy Linville, was involved in drugs and prostitution. He went by the nickname of "the Professor." On the other hand, much of the bribing alleged at city hall appears to have been small-time palm-greasing or simple favoritism. Such political bosses as existed—such as Ward "Doc" Scheumack—were insignificant compared with their counterparts back east.

The police force was indeed compromised. Some cops looked out for protected gamblers, pimps and mobsters. Some acted as bagmen. City commissioners tied to vice could count on most officers to look the other way or get them out of trouble. The police Zoot Suit Squad terrorized young Mexican American men.

The department and city were also still reeling from the 1944 murder of Patrolman David Lee "Star" Johnson, who was black, by Leonce "Frenchy" Navarre, a white detective who was rumored to have mob connections. Johnson and his partner Joe Davis, both in uniform, saw Navarre run a stop sign in the Deuce. Johnson approached Navarre alone, the two argued and Navarre shot Johnson multiple times, including in the back.

Like the southern town it still was, Phoenix empaneled an all-white jury that acquitted Navarre, and he returned to duty. A few months later, Johnson's partner Davis came to headquarters for revenge and shot "Frenchy" to death. After two trials, Davis was convicted of manslaughter and was paroled in 1947. Such things didn't happen in Phoenix, or so the respectable Anglo population thought, and the shock was severe—although boosterism soon forced the event into the memory hole for decades.

More clear is that the old system of governance was fitted to a much smaller and less complex place. Its flaws were sharpened and exposed by the demands of the war and immediate postwar years. A growing city needed more services delivered efficiently and not ones that ebbed and flowed with every election. The situation was also bad for business and tourism.

Foremost among those who wanted wholesale change was Frank Snell, who had been practicing law in Phoenix since the late twenties. His partner Mark Wilmer was a gifted litigator. Snell's talents lay elsewhere. He became the premier city booster, deal-maker, fixer and driver behind a takeover of city hall, especially after the betrayal following the "card room putsch."

Joining him were the downtown merchant princes, department store owners Robert and Barry Goldwater and Harold Diamond, along with Harry and Newton Rosenzweig and Charles Korrick. Banker Walter Bimson, builder Del Webb and chamber of commerce president Charlie Bernstein

rounded out the group. They found a highly effective ally in Eugene C. Pulliam, new owner of the *Arizona Republic* and *Phoenix Gazette*. Pulliam was a crusading conservative publisher from Indianapolis, a Republican and part of a growing regional shift. Earlier decades had seen heavy migration from the South; now it would shift to the midwest.

Together, the businessmen advocated a city government based on the practices put forward by the National Municipal League and Louis Brownlow's American Society for Public Administration. These had been implemented successfully in Cincinnati and other cities. With the help of the Pulliam newspapers, this modern system was contrasted with the antiquated status quo, openly spoils-based, where the victors took care of their supporters.

If those advocating a complete revamping of city government represented the Arizona Club, their opponents were more diverse, including social reformers such as Father McLoughlin, labor unions and especially small-time businessmen. For example, "Boss" Scheumack, as his critics styled him, was the owner of Valley Paint and Supply. This coalition lacked the resources of the big business leaders. For example, a competing daily paper started by FDR's daughter Anna and her husband, John Boettiger, the *Arizona Times*, attempted to provide a liberal voice in the city. It lasted less than two years. Unions still were a force in Phoenix, especially with the railroads and construction. But paralyzing postwar strikes left them out of favor, even with Harry Truman. Arizona was the first state in the west to pass a Right to Work Law, and the Taft-Hartley Act wounded organized labor nationally. The war, growth and newcomers from the midwest scrambled the old order. Returning veterans formed a new political bloc more favorable to the GOP.

It was a time when new ideas fermented. Phoenix was also influenced by national political trends, including exhaustion after fifteen years of near total control by the Democratic Party. Republicans won majorities in Congress in 1946 and expected to take the White House two years later. Truman pulled out a victory running against the Do-Nothing Congress, but national politics were more competitive than at any time in recent memory. In her book *Sunbelt Capitalism*, Elizabeth Tandy Shermer focuses on the battle for control of Phoenix city hall as a forerunner of rising national conservative Republican strength. And indeed, in 1952, Councilman Goldwater narrowly beat incumbent Ernest McFarland for the U.S. Senate ("Mac" was as dragged down by the unpopularity of Truman and the Korean War as Goldwater was a clear foreshadowing of conservatism's coming triumphs; Mac came back to Arizona and was elected governor).

Most of Phoenix's tumult took place within the Democratic Party, the GOP being the historically weaker competitor. Battle lines were not hard. Alliances shifted, blended and broke up. By the late 1940s, both sides wanted to claim the mantle of reform, to amend or wholly remake the charter. We can only imagine the many strategy sessions and arm twistings that went on at such smoky places as the Hotel Adams coffee shop, the Hotel Westward Ho or Tom's Tavern. Many of the disagreements would seem arcane, anachronistic and obscure to us. Other frustrations with city government were practical, including the failure to anticipate and address the downtown parking crisis as gas rationing ended and automobiles increased.

Two waves of change settled the issue. In 1948, voters approved charter changes that created a six-member city council in at-large seats, members would have no administrative duties like the commissioners, the city manager position would be strengthened and elections would be nonpartisan. The platform's most appealing promises were businesslike government, low taxes and weeding out professional politicians. Young Democrats and young Republicans joined together to support the changes while the junior chamber of commerce helped sell the plan to the public. Districts and a strong mayor were considered but not recommended. The next year, a solid slate of reform candidates selected by the one-hundred-member Charter Government Committee (CGC) won in a landslide. They included Nicholas Udall, Harry Rosenzweig, Barry Goldwater and Margaret Kober, the first woman elected to council.

Charter candidates would rule city hall for the next quarter century.

WHAT KIND OF CITY?

The postwar downturn abated, and large numbers of newcomers began arriving in Phoenix. New houses were air conditioned, too, and demand for the machines seeded a major local manufacturing sector. Among the companies was Goettl Brothers, started in 1934 by the tubercular John Goettl making evaporative, or swamp, coolers. His brothers joined him, and by the early fifties, they operated the largest air-conditioning factory in the world. Other air-conditioning makers included Palmer Manufacturing, Polaire Cooler Company, Wright Manufacturing, International Metal Products and Mountainaire. Evaporative units were initially the biggest sellers but were soon eclipsed by refrigerant-based units. By 1951, more than 90 percent

The Phoenix poolside lifestyle that was heavily sold by boosters after World War II. *Herb and Dorothy McLaughlin Collection, Arizona Collection, Arizona State University Libraries.*

of homes in the state were air conditioned, with most of the units made in Phoenix. Air conditioners were also exported to other states.

Residential construction revived, and the pace of building new subdivisions increased. These were small by future standards—Hugh Evans's 176-lot Cavalier Homes was considered large. Private enterprise received help from larger forces. Consumer demand stifled by the Great Depression revived, and Americans had money to spend as the ascent of the largest middle class in the history of the world began. Washington continued to help, too. The GI Bill, whose prime mover was Arizona senator Ernest McFarland, the Senate majority leader, included low interest rate Federal Housing Administration loans to veterans. Unfortunately, this often didn't extend to African Americans who had served. Like many cities, Phoenix was redlined and covered with race-restricted deed covenants, and these veterans were prevented from joining in the nascent suburban dream.

Meanwhile, the Cold War began and chilled further when the Soviet Union exploded an atomic bomb in 1949. The next year, the Korean War

began. The Truman administration began a massive rearmament that revived, and in some cases expanded, defense industries that had withered after the end of World War II. The prospect of nuclear bombing also caused Washington to encourage decentralization of defense plants. This provided a huge boost to the Phoenix economy. With both measures—cheap loans for housing and increased defense spending—the federal government once again helped push Phoenix into the future.

In 1950, Phoenix entered the ranks of the nation's one hundred most populous cities. Parking complaints notwithstanding, the central business district enjoyed the greatest sales tax take of the entire state. In addition to the Phoenix Open and Rodeo of Rodeos, leaders attempted to give to the city national prominence by hosting a college football post-season game, the Salad Bowl, played from 1947 to 1955. The Phoenix Symphony was founded in 1947. The aging streetcar system was replaced with new buses. Thanks to a professional city manager and more efficient government, Phoenix won its first All-American City award from the National Municipal League in 1951. The effort to build a new city library had begun even before the CGC's win

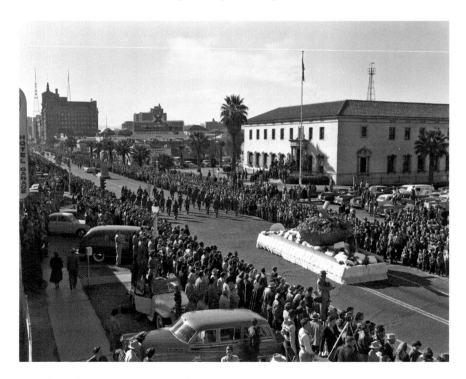

Salad Bowl Parade, 1951. *Herb and Dorothy McLaughlin Collection, Arizona Collection, Arizona State University Libraries.*

of city council. With land donated by Maie Bartlett Heard at Central and McDowell, leaders—including Newton Rosenzweig, Walter Ong, Walter Bimson, O.D. Miller and Barry Goldwater—began a fundraising campaign. Voters approved $1.35 million in library bonds in 1948. The result, opening in phases during the fifties, was the Phoenix Civic Center, with a large

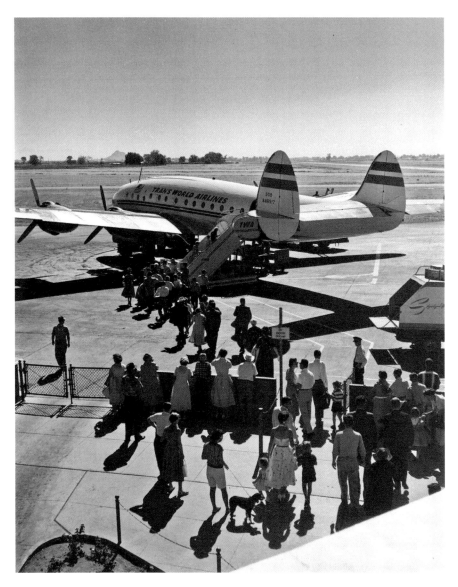

Passengers board a Trans-World Airlines Constellation at Sky Harbor Airport, circa 1950. *Herb and Dorothy McLaughlin Collection, Arizona Collection, Arizona State University Libraries.*

public library, a little theater and an art museum. It was the most impressive physical representation of a modern city on the move.

Tourism also revived, including with motorists who entered the oasis from long desert drives to find neon-lit corridors packed with motels, motor courts, restaurants and souvenir shops on Van Buren Street, Grand Avenue and Buckeye Road. Streamlined passenger trains began to call at Union Station, part of a massive modernization by the railroads. But while they were heavily taxed, the federal government subsidized roads and the growing airline industry. Sky Harbor increasingly became vital to Phoenix. A new terminal and control tower opened in 1952, and by 1957 the airport boasted forty-two departures daily.

The city council also focused on cleaning up the police department. The city manager and Mayor Hohen Foster leapfrogged Lieutenant Charlie Thomas over more senior officers to become chief in 1954. Thomas recalled feeling "a little sick to my stomach" when he learned of his selection, knowing the magnitude of the job. Ten minutes after being sworn in, Thomas called several cops to his office and gave them the choice of resigning or being fired. All were gone within two weeks. It was the first step in creating an ethical and professional department. Thomas served until 1963.

Still, Thomas admitted he couldn't clean up the entire department, only make some headway. Years after Thomas retired, a young patrolman stopped a suspicious man with a large amount of cash that he couldn't explain. Taken to police headquarters, the man waited to be questioned while the money was inventoried. After a phone call came in, a superior told the officer to give the man his money and let him go. The young cop had unwittingly interfered with a protected bookie's runner. In its self-image, Phoenix was a wholesome city while Tucson was the mafia town. In fact, the mafia enjoyed a large presence in Phoenix going all the way back to Al Capone. Along with being a safe haven for organized crime "back office" work from Las Vegas, land fraud was a major illegal business. Phoenix was said to have more mobsters per capita than New York in the late fifties. This was punctuated in 1958 when Gus Greenbaum and his wife had their throats slit while preparing dinner at their Encanto home; the hit men stayed and ate steak dinners. Greenbaum was suspected of skimming the till from Vegas casinos.

After the gangland bombing murder of *Arizona Republic* investigative reporter Don Bolles in 1976, the journalism group Investigative Reporters and Editors (IRE) produced a series on the pervasive criminal element in Phoenix. While the *Republic* produced some distinguished work on the killing,

especially by Al Sitter, it refused to run the IRE project (*New Times* did). One reason was IRE's contention that some of the city's leading citizens were involved in organized crime, including Harry Rosenzweig and the Goldwater brothers. Suspicion also fell on Del Webb, who built Las Vegas casinos. But the proof was inconclusive. Webb and Barry Goldwater especially liked to run with a fast crowd, and the line was blurred between the law-abiding and the mafia. There remains no evidence that these Phoenicians were directly involved in the mob.

According to the census, Phoenix in 1950 ranked ninety-nine among the largest cities, with 106,818 residents in seventeen square miles. The city's density was similar to modern Seattle, but this was misleading. Two-thirds of the valley's population lived outside the city limits, many in unincorporated county areas. This was also where most new residential and industrial construction happened, scattered amid the fields, citrus groves and desert. While Phoenix had a zoning code, the county was much more permissive and relatively less expensive. Even venerable institutions began to move north, sometimes out of the city. For example, St. Joseph's Hospital moved to a large, modern building in the early fifties on the north side of Thomas Road, almost three miles from the old town center and on the city's edge. The hospital had acquired the ten acres from the owners of the Central Dairy.

City leaders looked east to older cities surrounded by suburbs and feared Phoenix becoming landlocked and starved of future growth and tax revenues. The immediate concern was not about existing towns such as Tempe or Glendale; both were separated from the city by a considerable distance. The one exception was Scottsdale, named after Chaplain Scott and only incorporated in 1951 with two thousand residents. Scottsdale was already landlocked to the east by the Salt River Pima-Maricopa Indian Community. Its only chance to secure future expansion seemed to move west, and that was territory the city of Phoenix also coveted. The two fought for years before reaching a temporary peace in the mid-sixties, with larger Phoenix getting most of what it wanted.

Otherwise, city leaders worried about many proto-communities in the county closer to the city limits or in a position to block Phoenix's geographic growth, especially to the north and west. If they incorporated, the city would be hemmed in. On the other hand, annexation was expensive and sometimes contentious in the courts and legislature. One early battle was over absorbing the Phoenix Country Club and its exclusive surrounding neighborhoods into the city. Residents feared city taxes. It succeeded thanks to lobbying by Barry Goldwater, and as with most annexations, residents were happy with the new

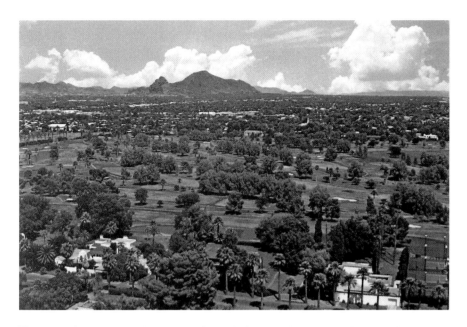

The oasis of Phoenix, looking over the Phoenix Country Club toward Camelback Mountain, circa 1955. *Brad Hall Art.*

city services. Some older manufacturers fought being brought into the city, and new ones scattered into unincorporated areas. In addition to property owners, the city faced private water companies demanding to be bought out.

Yet council members determined to embark on an ambitious physical expansion of Phoenix, an effort that gained speed and consisted of larger parcels by the end of the decade—the better to have an impressive showing in the 1960 census. The annexation became more aggressive as the fifties continued. The one unincorporated area most likely to become a separate town was Sunnyslope, north of the Arizona Canal. New construction made "the Slope" more affluent, but residents couldn't agree on incorporation despite repeated votes. It was absorbed by the city in 1959. Phoenicians were also wary of taking in the barrios and African American neighborhoods of South Phoenix. That annexation didn't happen until 1960.

Traffic was another major concern. To ease congestion, Washington, Jefferson, Third and Fifth Avenues were made one-way streets. Transit, however, was poorly funded, and the bus system was inadequate. City planners unveiled plans to widen virtually every major thoroughfare. The state began work on the Black Canyon Freeway, Phoenix's first, in the fifties, running north and south about a half-mile west of the capitol. State

highway officials also wanted to run an east–west freeway in front of the Hotel Westward Ho; its alignment was soon moved north by a few blocks. Historian William Collins estimates that street widening ripped out even more shade trees than the twenty thousand lost when the Salt River Project removed trees from the canal banks.

Thus, by the mid-fifties, Phoenix's spatial configuration had been radically changed. Also certain features were set in place—some by policy and others by absentmindedness—that would become defining aspects of the future metroplex. It would be based on the private automobile, with wide streets for easy mobility. Also, the mixed-use, walkable central core would give way to subdivisions leapfrogging across the farmland in a spread-out, decentralized city where zoning rigidly separated residential and commercial uses.

THE BUILDERS

Del Webb, by now a millionaire, continued as the city's most prominent builder. For example in 1957, he unveiled the modernist Phoenix Towers on Central Avenue, a few blocks north of the new civic center. Even downtown saw renewed construction after the war, including new floors added to Switzer's, Korrick's and J.C. Penney, as well as an entirely new building for Hanny's, a sleek mixture of International and Moderne styling. The Hotel Adams built a parking garage, and the Westward Ho added a new pool and an expansive annex aimed at guests with cars. New headquarters buildings for First National Bank and the Arizona Bank went up, as well as a glass-skinned annex to the Security Building. Inside the First National headquarters lobby, artist Jay Datus was commissioned to paint an enormous mural titled *Foundations of Confidence*. Valley National Bank's chief Walter Bimson built a penthouse atop the Security Building until his wife convinced him to move to Paradise Valley, which was attracting more of the city's elite. The city was pulling apart, and a new generation of builders would give it a fresh look and feel.

The most influential residential developer was John F. Long. A towering figure among those who built Phoenix from a small farm town into one of the nation's largest cities, he brought affordable, pleasant suburbia to postwar Phoenix and paved the way for widespread home ownership. Taking mass-produced housing beyond its Levittown roots, Long was an innovator of national consequence. His signature project

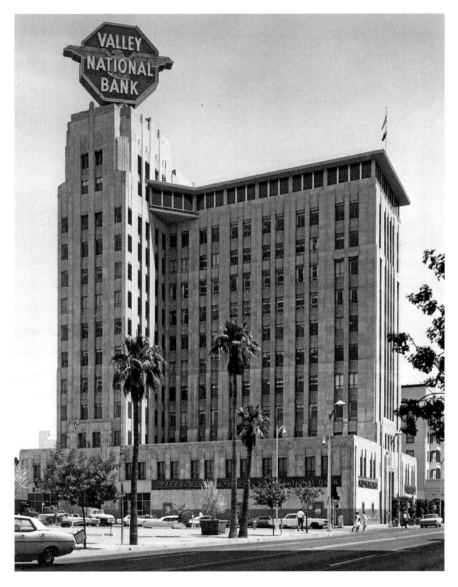

Even though construction boomed outside downtown in the late 1950s, Valley Bank kept its Art Deco downtown headquarters and added a revolving sign, said to be the world's largest. *Brad Hall Art.*

was Maryvale—named after his wife, Mary Tolmachoff Long—built on farmland west of the city limits starting in the mid-'50s. It eventually encompassed several square miles. The modern, ranch-style houses with several exterior designs, all-electric kitchens and swimming pools

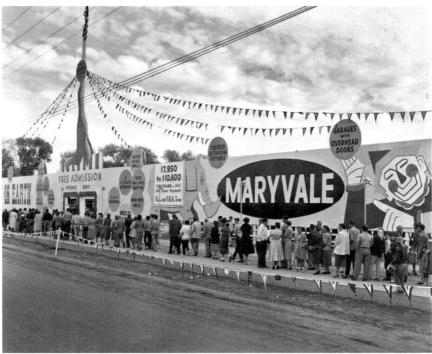

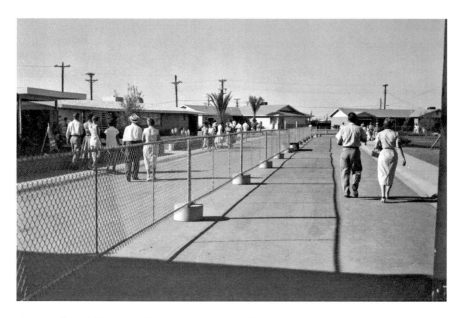

A street of model homes at Maryvale, circa 1958. *John F. Long Properties, LLLP.*

Opposite, top: John F. Long built Phoenix's first mass-produced development and named it Maryvale, after his wife, Mary Tolmachoff Long. The two are shown circa 1958. *John F. Long Properties, LLLP.*

Opposite, bottom: Prospective buyers line up outside the model homes of Maryvale, circa 1958. *John F. Long Properties, LLLP.*

contrasted sharply with the out-of-fashion bungalows and period revival houses of central Phoenix. So did the novel curvilinear streets and cul-de-sacs. Maryvale included a shopping center, civic clubs and, eventually, an industrial-office park. After Maryvale was annexed by Phoenix, Long served as a city councilman.

Long influenced other builders, although many brought their own unique approaches and looks to their houses. Among the most important were Ralph Staggs, Clarence Suggs, John Hall, Frank Knoell and Gene Hancock. They also built new subdivisions in Tempe, Mesa and other valley locations. Henry Coerver built large houses amid the citrus groves north of the Arizona Canal in northeast Phoenix. His Arcadia district would become one of the most beautiful and coveted areas in the valley. These local builders set the model for the valley for decades, although many were winnowed out by housing downturns in 1960, 1974 and especially 1990. Along with a house, they were selling a lifestyle, a miniature resort for every homebuyer.

Commercial building also underwent a dramatic change in the fifties, moving outside the traditional central business district. Already, east McDowell Road had been organically developing a miracle mile of mostly single-story retail buildings running from Good Samaritan Hospital at Tenth Street to beyond Sixteenth Street. More shops opened along Central Avenue north of the Westward Ho at Fillmore Street, the traditional boundary of downtown. Little attempt was made to channel development, so it popped up all over. Still, because of the agricultural layout of the land, lateral canals easily lent themselves to become main avenues every mile and feeder streets every half-mile. As subdivisions leapt ahead, commercial builders created a common form with a grocery-anchored shopping strip about every mile.

The endeavor reached a new level with the development of Central Dairy, in today's midtown, a longtime agricultural business outside of town owned by the Geare family. With city development knocking close by at Thomas Road, some 224 acres were sold to Southern California developers who planned an enormous mixed-use project. In addition to three hundred apartments and seven hundred houses, the showpiece was a large, open-air shopping center called Park Central surrounded by abundant free parking. It opened in 1956, drawing Goldwater's and Diamond's department stores from downtown. Two miles north of downtown, Park Central was Phoenix's first mall.

In the forties, Phoenix had more than five hundred retailers arrayed in the compact central business district. These were close to movie theaters, hotels, coffee shops, restaurants, the Greyhound and Continental Trailways bus depots and Union Station. Although decline set in after the war, downtown continued its retail dominance until Park Central. Built for walking, downtown retail presented a new door every few steps. For example, here's a stroll on First Street between Washington and Monroe streets in 1956. Those two blocks were home to Russell Stover Candies, David's Shoes, Goldwater's, Hanny's, Dorris Hayman furniture, Montgomery Ward, Porter Mercantile, Barney's Garage, Cole Home Supply, Morris Athletic Supply, Richard Dean Jewelry, Tony's Shoe Shop, the Normandie Hotel, Thompson's Indian Shop and Phoenix Stamp and Coin. Offices were found in the buildings above many of these street-level shops. Now they would begin an inexorable decline.

Building an Economy

As early as the late forties, some Phoenix businessmen imagined creating a perpetual motion machine where population growth would create jobs, which, in turn, would bring more people and jobs in a virtuous cycle of sunshine-driven growth. With the new Right to Work legislation and lower living costs, couldn't Arizona raid the industrial base of the American heartland? No. The big factories stayed put in places such as Pittsburgh, Cleveland, Chicago and Dayton, where companies had huge sunk costs and large skilled workforces. Unions were wounded by Taft-Hartley, but private-sector membership in the American Federation of Labor and Congress of Industrial Organizations (AFL-CIO) continued to grow in the fifties.

To be sure, the city enjoyed a relatively diverse small-scale local economy, as partly examined at the end of Chapter 5. This satisfied its needs and exported certain goods, especially farm products and evaporative coolers. But aside from Reynolds Aluminum buying and reopening the wartime extrusion plant from Alcoa west of downtown and the air conditioning makers, Phoenix lacked enough big industry to satisfy the visions of becoming a major city. For a time, it appeared that Phoenix would continue to depend on three of the historic "four Cs" that drove the state economy: cotton, citrus and cattle (although not copper). Later, boosters would add another C for climate, but health seekers at this point were not enough to support many jobs. Tourism, while vital, had not yet entered its maturity as an industry.

Instead, three drivers emerged to transform the Phoenix economy. One was rising and sustained defense spending in peacetime, a first in American history. Williams Air Force Base, the only World War II training field in the valley that remained open after demobilization, was expanded. Luke Air Force Base was reopened. Facing what it saw as an existential challenge from expanding communism and the Soviet Union, the United States not only embarked on building large peacetime armed forces but also "military Keynesianism," immense federal spending on weapons and the uniformed services. Second was an aggressive effort by local leaders to recruit capital investment, eventually focusing on defense industries and especially aerospace. A third less discussed element was rising racial tensions back east as the civil rights movement intensified. As a city with a large Anglo majority and many small school districts, a legacy of the farm era, Phoenix became an increasingly appealing place for whites who wanted to escape integration pressures back home and, later, busing.

One of the earliest and most significant wins came when Motorola decided to invest in the valley. Co-founder Paul Galvin liked what he saw in Phoenix. Frank Snell said he was especially fond of the Camelback Inn resort. According to historian William Collins, the foremost scholar of the immediate postwar decades, Motorola research chief Daniel Noble fell in love with Arizona. "The decision to locate in Phoenix appears to have been made by Noble on a purely subjective basis," Collins writes. Perhaps, but spectacular sunsets and the magical interface of the oasis and the desert got help from Bimson at Valley National Bank, who helped finance Motorola's move; additional assistance came from the City of Phoenix and the chamber of commerce. In 1949, Motorola leased temporary office space in downtown Phoenix and started work on a plant at Fifty-Second Street and McDowell, nearly six miles east of downtown and near Papago Park. Noble oversaw the establishment of a solid-state electronics laboratory there. Motorola would build additional plants later in the fifties and eventually become the valley's largest employer.

Other coups didn't come immediately. Again, the lack of planning and investment in infrastructure held Phoenix back from grabbing some opportunities that came from the push to decentralize defense plants and then the boost in funding with the Korean War. Goodyear returned to its wartime plant in Litchfield Park. More significant was the 1950 return of Garrett's AiResearch, which waited for voters to repeal the tax on manufacturers' inventory (and, according to Collins, reject a measure that would have legalized gambling in the state). City leaders hoped it would make Phoenix as similar to Southern California's aeronautics industry but with cheaper costs. Yet it was only partly successful—the Glenn Martin Company and Hughes Aircraft "kicked the tires" but went elsewhere—and Phoenix missed the big wartime contracts from the early 1950s. More than dollars were at stake. Phoenix was, at best, taking two steps forward and one back; this was not a strategy that would make it a serious contender, no matter how cheap or close to California it was.

The Municipal Industrial Development Corporation (MIDC) was an ostensibly private organization established to provide a more disciplined and sophisticated approach to business recruitment, specifically for aeronautics companies. But affiliated with the chamber of commerce and the Charter Government Committee, it was in reality closer to a modern public-private partnership. For example, the organization raised $650,000 in seventy-two hours to purchase land for Sperry Rand adjacent to Sky Harbor Airport. City and state officials, including Governor Ernest McFarland, had

aggressively wooed Sperry, which made guidance systems for airplanes and missiles. "Mac" had personally assured Sperry executives of his support of eliminating sales taxes on the sale of manufactured goods to the federal government. But with MIDC, Phoenix was able to act with new urgency and effectiveness. Sperry agreed to come to Sky Harbor and went on to build an additional, much larger facility in Deer Valley, in far north Phoenix, to make flight control components.

Behind this, too, was Frank Snell. While overseeing his thriving law practice, he became the city's prime salesman, traveling to headquarters on the West Coast or back east, as well as hosting dinners for visiting executives at his home with his wife, Betty. Snell took them on tours of the valley, including to the Sombrero Playhouse, Spring Training (three teams played there by the early fifties) and horse racing, as well showing off the natural beauty and—outside of summer—fine weather. At the *Republic* and *Gazette*, Gene Pulliam championed corporate tax incentives to lure large employers. Together, Snell, Pulliam and Bimson had the power to achieve things like the quick fundraising to lure Sperry.

This more advanced approach to economic development also focused on Phoenix's disadvantages. The city itself lacked any four-year institution. Tempe's Arizona State Teacher's College, renamed Arizona State College (ASC) in 1945, did not offer the robust engineering school needed by Motorola and other technology companies. Nor did Phoenix have a national laboratory (a deficit that would never be filled). Through much of the fifties, valley leaders fought a long battle to gain ASC university status even as the college continued growing. They met vehement opposition from the University of Arizona and Tucson leaders. Also, in this era before the 1964 "one man, one vote" Supreme Court decision, rural state senators held enormous power. They tended to be hostile to urban interests and, coming from ranching and copper country, suspicious of the need for another university.

Grady Gammage, the president of ASC, was born in Arkansas but was another person drawn to Arizona for his health. After working his way through the university in Tucson, he became Winslow public school superintendent and taught courses at Northern Arizona Teachers College in Flagstaff. He took an administration job there in 1925 and was named president in 1926. In 1933, he became president of ASC and its passionate, tireless advocate. This was especially true in its drive to become a university. Perhaps helping its case, ASC's computer science program had been critical to Phoenix landing General Electric's new computer manufacturing operation in 1956. Two years later and with the support of Paul Galvin

and the Phoenix business leadership, Gammage campaigned statewide for a ballot initiative that would make that happen. It passed, and Arizona State University became another important element in the economic, as well as civic, growth of greater Phoenix.

By decade's end, Phoenix had achieved a prime ambition: it was the leading city of the Southwest. To El Paso's 277,000—an impressive 112 percent growth rate—Phoenix clocked 439,170 souls after growing an astounding 311 percent. Phoenix had become a big city. The 1960 census placed the city as America's twenty-ninth largest—ahead of Newark, Louisville, Oakland and Fort Worth among others—and within striking distance of Denver. The perpetual motion machine, the growth machine, was running hard and, it seemed to most, without flaws.

Leaders trumpeted Phoenix's success in attracting "clean industries." They could also claim some social advancements. Lincoln Ragsdale, the former Tuskegee airman, broke the color barrier in 1953 by moving to the exclusive Encanto area. Despite hostility from some white neighbors, Ragsdale, by then a wealthy funeral director and businessman, stayed. Later, he and his family moved to Paradise Valley. Ragsdale was also a leading civil rights leader.

The 1950s also saw the first African Americans elected to the state legislature—Hayzel Daniels and Carl Sims. Daniels, from Tucson, was the first black to graduate from the University of Arizona School of Law and be admitted to the state bar. Sims, a one-time Maricopa County deputy, was a strong voice for school integration. Indeed, because of state court decisions and pressure from image-conscious boosters, Phoenix ended de jure school segregation ahead of the national *Brown* decision in 1954. The CGC helped elect the first Hispanic city councilman, Adam Diaz. Chinese Americans moved rapidly into the mainstream. Before chain convenience stores, they owned scores of groceries all over the city. In 1943, Walter Ong had founded the Retail Grocers Association of Arizona, which came to have both Anglo and Chinese members. In 1956, he was named Phoenix Man of the Year. Wing F. Ong had been elected to the state legislature in 1946, a national first. The city's tiny Chinatown disappeared as Chinese were free to move anywhere. Returned from internment, Japanese farmers turned Baseline Road into a sweeping vista of flower gardens that attracted visitors from around the country.

Indeed, for all the urban growth, agriculture held its own in the Salt River Valley, rising to 485,000 acres under cultivation in 1955 and 519,160 in 1959. No wonder so many Phoenicians would look back fondly on these years, for they seemed to offer the best of old and new.

CITY OF THE FUTURE

P hoenix seemed like an unstoppable force for the next thirty years. It
was a new, growing, sparkling metropolis. Visitors and newcomers
from the older cities of the east would comment on how clean the streets
were. Honking one's car horn was considered impolite. Especially after the
assassination of John F. Kennedy, much of America seemed caught in endless
cycles of conflict, including urban riots, protests against the Vietnam War,
the disappointment of urban renewal and white flight from venerable cities.
Phoenix appeared to offer an optimistic counterpoint, a welcoming and
fresh place where the middle class, wealthier than ever after the Depression,
could start over in safety and with new opportunities.

The closest that the national tumult of the sixties came to most of the
Anglo population was the television screen. Native son Barry Goldwater
ran for president in 1964 but was soundly defeated by President Lyndon B.
Johnson. Even Pulliam declined to endorse Barry. The author was a student
at Kenilworth School, Goldwater's alma mater, during the campaign. But
only he and another student wore Goldwater buttons amid a sea of LBJ
buttons. On October 11, 1964, Johnson visited under, the *Republic* reported,
"the tightest security lid ever clamped over Phoenix." He drew a crowd
of twenty thousand. Goldwater was consigned to a small fundraiser at the
Heard Museum; he announced the gift of $200,000 worth of Hopi Kachina
figures to the museum.

Downtowns were in decline everywhere. In Phoenix, retail was abundant
and sheltered in new air-conditioned malls. After Park Central came the

At Chris-Town Mall, a model of the new Valley Center is shown off. It is part of an effort to revive downtown. *Brad Hall Art.*

enclosed and air-cooled Chris-Town and Thomas Malls, as well as shady Biltmore Fashion Park, followed by Tri-City Mall in Mesa, Scottsdale Fashion Square and Los Arcos mall in Scottsdale. Metrocenter, the area's first "super-regional" mall, opened in 1973 on the city's northern

fringes. Even though Phoenix had only two freeways—the original Black Canyon that looped southwest of downtown into the Maricopa Freeway to become Interstates 17 and 10—driving was easy on the wide streets. In the height of the automobile age, when gasoline was cheap until the oil embargoes of the seventies, Phoenix was a driver's dream. Driving propelled one of the city's traditions, Cruising Central, where high-school students showed off their cars and met potential dates from other schools on Friday and Saturday nights, stopping in for shakes and burgers at the large Bob's Big Boy at Central and Thomas.

The business district spread out on Central north from downtown into new skyscraper developments in midtown. City leaders imagined it would become like Wilshire Boulevard in Los Angeles. First came the Guaranty Bank Building in 1960, developed by David Murdoch just north of Osborn, more than two miles north of downtown. An International-style box sheathed in a turquoise-and-white skin, it became the tallest building between El Paso and Los Angeles. Then Harry and Newton Rosenzweig, the downtown merchant princes and political movers, developed Rosenzweig Center farther north at Clarendon. Located partly on the old pioneer Rosenzweig homestead, the complex of skyscrapers included the Townhouse Hotel by Del Webb. Across the street from Park Central, the Mayer family erected twin towers, the taller one with an outside elevator to the top and the shorter one sporting the Phoenix Playboy Club. The distinctive "punch card building" on the northeast corner of Osborn followed (with additional floors added in the 1970s), becoming the headquarters of Western Savings. Developers envisioned two curving towers there, facing each other like cupped hands, but only one was built. The Regency and Camelback towers added high-rise apartments to the avenue. Uptown Plaza shopping center at Camelback Road became the retail bookend (it included Bill's Records, a Piggly Wiggly market, Navarre's restaurant and Webster's Hobbies, which had a magnificent model railroad layout).

The death of the American passenger train seemed to accentuate the irrelevancy of downtowns everywhere. Phoenix still had eight daily trains into the mid-sixties, but after postal contracts were canceled, the station only saw a much-diminished Sunset, cut back to thrice-weekly by the Southern Pacific. For the first time since the mid-1920s, Union Station was no longer open twenty-four hours a day. The action was at Sky Harbor, where an expansive second terminal opened in 1962 with a grand mural of a Phoenix bird overlooking the airy waiting room. Boeing's 707 jet, which

revolutionized air passenger service, was a perfect fit. Distance and isolation, Phoenix's long-standing adversaries, were vanquished.

Thanks to Social Security, the postwar prosperity and FHA loans, older Americans began looking for a more pleasant retirement than previous generations had imagined. They found it in 1960 when Webb opened his revolutionary Sun City retirement community northwest of Phoenix. It offered five models of homes, along with a shopping center, a community center and a golf course. Photos of carefree seniors driving the sunny streets in golf carts helped set off a huge migration that became an essential part of the growth machine. Other developments followed around the valley, and again, more than houses were marketed. It was a lifestyle in a warm "active adult community," a pleasant alternative to snow and discord back home.

Big-city culture was slower in coming, although the Phoenix Art Museum opened in late 1959 and the Phoenix Symphony began playing in the stunning Grady Gammage Memorial Auditorium on the ASU campus after it was completed in 1964 and named for the late university president. It is the only public building in the state designed by Frank Lloyd Wright, although he was commissioned for several houses. Mid-century architecture flourished in Phoenix, from homes to commercial buildings. Valley National Bank considered every branch as a gift to the community and commissioned a unique design for each. The city's coffee shops sparkled with Space Age pizzazz, such as the Helsing's on Central, a work by John Sing Tang, the city's first noted Chinese American architect. Distinguished Phoenix architects included Ralph Haver, Al Beadle and Bennie Gonzales.

Beyond Spring Training, big-city sports began arriving in 1968 with the Phoenix Suns, playing at the new Veteran's Memorial Coliseum at the state fairgrounds. In coming years, as the city fell in love with the NBA team, the arena would be nicknamed "the Madhouse on McDowell." The valley offered other new entertainment, especially the amusement park Legend City, which opened in 1963 on the border of Phoenix and Tempe, and Big Surf, a water park including an artificial wave machine, in 1969. The Fiesta Bowl, a post-season college football game that became one of the major bowls, began in 1971.

For all the new development, Phoenix retained a unique feel with much of its oasis charm and elements of a small town. Shady acreages reached by crossing culverts over open laterals persisted in north-central Phoenix. Downtown, a few merchants resisted the pull of the north, and through the sixties, the Fox and Paramount (Orpheum) movie palaces remained opened. The area retained a variety of offices and commerce, including the railroads,

Downtown Phoenix was in decline in 1970, but the shops lining Central Avenue still have some foot traffic. *Herb and Dorothy McLaughlin Collection, Arizona Collection, Arizona State University Libraries.*

warehouses, bus depots, headquarters of the state's largest banks—including the Art Deco Professional Building, home of Valley National Bank with its huge revolving neon sign—law firms and government. Newspaper hawkers called from street corners.

While they accepted a changing downtown as inevitable and profited from the city's horizontal growth, the business leadership, although aging, refused to allow its death. Valley National Bank's Walter Bimson resisted efforts to build a new headquarters at Osborn and Central in midtown. Instead, he gave the go-ahead for Valley Center downtown, a 483-foot skyscraper appearing like a bundle of prisms. It was completed in 1973 and remained the city's tallest

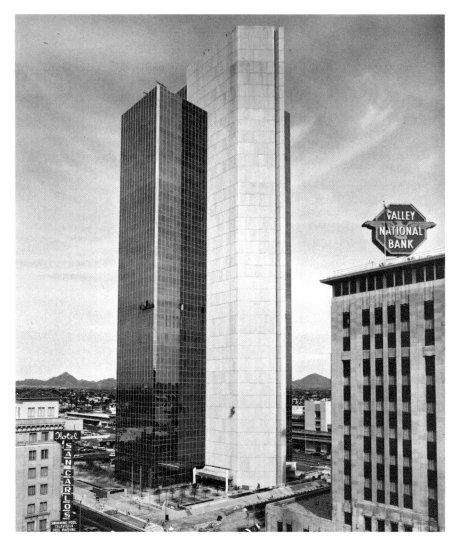

Valley Center, the new headquarters of the state's largest bank, is almost complete in 1972. *Brad Hall Art.*

building in 2015. The other two big banks also built new towers. The leaders and Eugene Pulliam's newspapers also supported a convention center and civic auditorium, built where much of the Deuce lay, as a revitalization tool. Phoenix Civic Plaza, which included the center and Symphony Hall, opened in 1974 followed by a new Hyatt Regency and Hotel Adams.

The *Republic* and *Gazette* building stayed in the core, too, as did most of the television stations through the 1980s. KPHO was most known for the

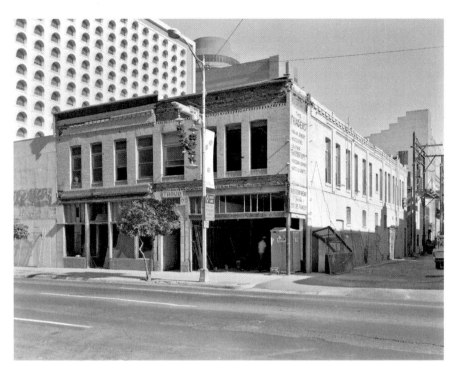

Despite revival efforts, many historic structures such as the Stroud Building (shown in 1984), were demolished. *Library of Congress.*

Wallace and Ladmo show (it went through several name changes), which ran for decades. Ostensibly a kids' show, it was filled with plenty of adult satire about local politics and issues. The regular cast featured Bill Thompson as Wallace, Lad Kwiatkowski as Ladmo and Pat McMahon. Wallace—or Wall-Boy, as Ladmo called him—was the host and butt of much humor but actually the pioneering genius behind the show. Ladmo was the everyman or everykid, full of fun and mischief. McMahon played a host of characters, many of whom gave the show its bite. Among them was Gerald the brat, the nephew of the TV station's general manager; Aunt Maud, the doddering, bad driver old coot from Sun City; biker Bobby Joe Trouble; Captain Super, a parody of assorted caped heroes; and Boffo the Clown, who hated children. While children elsewhere had their local clown or cowboy shows, young Phoenicians developed a much more sophisticated wit.

Meanwhile, the city was still surrounded by belts of agriculture. One could drive for miles and never leave the orange groves. Orange blossoms scented the air in March, and everyone who didn't have citrus trees at home could stop at a roadside stand and buy boxes of oranges, grapefruits, lemons,

melons and dates. A weekend drive to Baseline Road to buy cut flowers from the stands operated by Japanese American growers was almost mandatory. From there, a person looked north across the colorful fields to horse pastures, groves, downtown and, beyond, the rough bare mountains and the remnants of the frontier stretching in all directions. Well into the early eighties, most of Arizona outside of Phoenix and Tucson was wild and empty.

GOVERNING THE CITY

Candidates selected by the Charter Government Committee ruled city hall through the mid-seventies. Yet while city council had been the jumping-off point for Senator Barry Goldwater, a father of modern conservative politics, complex urban issues defied any fixed ideology (throughout his life, Goldwater supported every city bond measure). The CGC mostly delivered on its promises of a businesslike city hall, pro-growth policies and a council filled with civic-minded individuals rather than professional politicians.

Taxes were certainly lower than many eastern cities, but this required a certain sleight of hand. Already it was clear that growth did not pay for itself. Areas annexed in the fifties and after were often suffering from the sub-standard services of the county. Streets had to be paved and widened, curbs and gutters built, streetlights and traffic lights installed or upgraded and in many cases septic systems replaced with modern sewers. Most importantly of all, the city's water system had to be continually modernized and extended.

Mayors and city councils avoided large tax increases by grabbing all the federal money for infrastructure and poverty programs they could. It didn't matter whether the nominally nonpartisan leaders were Democrats or Republicans. The GOP was gaining increasing power in the city and state thanks to migration and national political changes. So, too, was the John Birch Society, although the rightwing group that considered President Dwight Eisenhower a communist appeared to be a minor, if vocal, force.

There were, however, limits to what Phoenix could get from Washington. The city repeatedly failed to pass a housing code, thus failing to qualify for federal funds for slum clearance and new public housing. Here, the opponents were not only some developers but also minority homeowners who feared losing their houses. One iteration of the code would have allowed city inspectors to enter a house "at all reasonable times." This offended nearly everyone and was quickly withdrawn.

The housing code provoked the first serious challenge to the CGC. In 1961, the Birchers mounted a slate of candidates in the 1961 elections. Led by the Reverend Aubrey Moore, they were part of the Stay American Committee (SAC). To them, the CGC's candidates were stooges of a one-world government conspiracy—if not outright communists. Public improvements were a threat to freedom. The National Municipal League was a stalking horse for totalitarianism. Schoolchildren collecting funds for UNICEF was a sign of the United Nations' designs on Phoenix. Zoning, so the group implied, was the first step toward Bolshevism. The CGC beat back the challenge only to face another one from liberals in 1963.

In truth, fast growth was causing the government to put off much needed investment. For example, the bus system was wholly inadequate, but popular Mayor Milton Graham and the car-centric planners at city hall opposed improving it. And challenges were coming from beyond the normal realm of delivering city services. Builders had been lusting after Phoenix's iconic Camelback Mountain since 1950, when banker Frank Brophy floated the idea of putting a resort there. A revolving restaurant on the top of the peak was another idea. Meanwhile, expensive custom-built houses were marching up the mountainside.

Camelback wasn't protected like the South Mountains. It wasn't even in the city when a preservation movement began in the mid-fifties, led by Louise Woolsey of the Garden Club of Phoenix, Bonnie Upchurch and Mrs. R.C. Sadler. They hoped to stop development above 1,600 feet (the summit is 2,704) and received invaluable help from the county's planning and zoning commission chairman H.S. "Casey" Abbott. Knowing the board lacked legal standing to block development, he stalled it by invoking safety concerns. Unlike the other mountains around Phoenix (or even the camel's head), the bulk of the mountain had a fault line running through it. This bought time for fundraising, which included collecting coins from schoolchildren.

After his defeat in the presidential election, Goldwater returned home and aggressively took up leadership of the movement to save Camelback. The target was $300,000. Biographer Peter Iverson recounts that Barry said, "If we ruin Camelback, ever afterwards people will think of Phoenix as the city that made something ugly of the most beautiful thing it had." He twisted prominent arms, including Frank Lloyd Wright, and even won a famous $1,000 contribution from his brother, Bob. The latter wagered that Barry couldn't learn to play "Silent Night" on a trombone. Barry not only did but also played it at a high-school dance while wearing a Beatles wig. But private funds were not enough, and federal money filled the gap. Lady

Bird Johnson and Interior Secretary Stewart Udall of Tucson presented the check to Phoenix officials in 1968. It was, historian William Collins quipped, "the Great Society coming to the rescue of Goldwater's special project." Camelback was saved above 1,800 feet, and the city bought adjacent Echo Canyon, an important trailhead for hikers up the mountain today.

Preservationists next moved to the nearby Squaw (now Piestawa) Peak, North Mountain and the rocky ground around them. This was a fight that would engage city leaders, civic stewards and large amounts of money until well into the seventies. With large numbers of property owners, mining claims, lawsuits and even the need for state voters to allow Phoenix to raise its debt limit, it was an even more complex battle than the one that saved Camelback. Its successful completion was an accomplishment and also brought to prominence the parks board head, Margaret Hance. She was elected to the city council on the CGC slate in 1971.

General Electric's computer manufacturing, one of the city's most promising technology gains, was gone by 1970. But a few years before, Phoenix staged a different kind of coup when Chicago's Greyhound Corporation announced it would move its headquarters to the desert metropolis. It located in a new tower at Rosenzweig Center, Phoenix's first Fortune 500 headquarters and, Phoenicians assumed, the first of many corporate centers that would follow.

THE UNDERSIDE OF PARADISE

The fast expansion of Phoenix helped many Anglo residents to believe the city had no slums. Yet south of Roosevelt Street, where most of the city's Mexican American and African American population lived, poverty, substandard housing, inferior city services and poorly funded schools defined the inner city. The situation was even more serious in South Phoenix, where the city's most toxic industries were concentrated along or near the Salt River bed. In his 2011 book *Bird on Fire*, Andrew Ross examined the problem in detail. He concluded, "South Phoenix ranks among the most striking case studies of environmental injustice to be found among large American cities."

Hispanic barrios such as Golden Gate around Sacred Heart Church, Campito, Cuatro Milpas, La Sonorita, Harmon Park, El Campito, Central Park, Green Valley, San Francisco and Grant Park were historic and beloved by their residents. But they lacked adequate investment by the city and

Sacred Heart Church is all that remains of the Golden Gate barrio, which was cleared for Sky Harbor International Airport. *David William Foster.*

private sector, and most were on the way to being carelessly destroyed by freeways and airport expansion.

Despite the go-go years, poverty remained entrenched, minority unemployment high and opportunities limited. Martin Luther King Jr. chose South Phoenix for a march to highlight poverty in the mid-sixties. Some prominent Anglo ministers joined him, to the displeasure of much of the city's leadership. One was Kermit Long of Central Methodist Church, a bastion of the city's establishment. For weeks after the march, anti-King protestors picketed the church. (Interestingly, Black Muslim leader Elijah Muhammad kept a winter home in Phoenix.)

The ugliness involved some of the city's most respectable Anglo citizens. Future chief justice William Rehnquist was among Republicans who challenged black and Mexican American voters at the polls in the mid-sixties. The Voting Rights Act of 1965 outlawed literacy tests, but Arizona kept one on the books until 1972.

Nor did Phoenix escape the riots of the decade. On July 25 and 26, 1967, riots occurred in the inner city, including around Eastlake Park.

Police responded to at least one sniper incident. Although the newspapers downplayed the event, the Johnson administration's Kerner Commission called it "a major disturbance." Calm was restored thanks to the Reverend George Brooks; Mayor Graham also held a community meeting at the park. Violence erupted between black and Latino students at overcrowded Phoenix Union High School in 1970. By then it was a minority-majority school, and the tension came despite rising collaboration between black and Latino community leaders.

Phoenix had been home to a chapter to the League of United Latin American Citizens (LULAC) since 1941. The nonprofit Friendly House, aimed at helping new immigrants, went back to 1920. But Hispanic activism grew with the formation of Chicanos Por La Causa (CPLC), an organization to confront discrimination and improve conditions. It led a boycott of the school to force improved safety and initiate programs aimed at helping minority students. The organization included numerous future leaders of both the Hispanic community and in politics, including Alfredo Gutierrez and Joe Eddie Lopez. CPLC went on to receive federal and city funds to initiate programs in the Hispanic community and remains an important civic organization.

Political gains did come, albeit slowly. The CGC chose teacher Morrison Warren to become the city's first African American city councilman in 1965. That came after the scare of the previous election, when a liberal slate including Lincoln Ragsdale launched a credible challenge to the CGC. Calvin Goode, an African American accountant who remembered picking Arizona cotton as a boy, joined the city council in the 1970s and served for twenty-two years. Rosendo Gutierrez was also a prominent member of the council. Several Hispanics and African Americans would be elected to the state legislature by the seventies. Most notable among them were Alfredo Gutierrez (no relation to Rosendo), the former student activist and CPLC member, and Art Hamilton, who grew up in the Henson homes. Gutierrez went on to become Democratic leader of the state Senate, while Hamilton was in the Democratic leadership of the House.

Yet another political problem that held Phoenix back was the disproportionate power of conservative rural legislators, most of them Democrats. This changed with the "one man, one vote" U.S. Supreme Court ruling of 1964. Two years later, Phoenix voters elected businessman Burton Barr to the state house, and soon he became Republican leader and an influential force for cities, where most Arizonans lived. In a few years, when Gutierrez became Democratic leader in the state senate, the two formed a

close partnership that modernized state government and passed bills that addressed urban issues such as funding for transportation and education and finally creating a state Medicaid program. "It was a coalition," Gutierrez said, "between urban Republicans and urban Democrats."

The troubles under the surface of Phoenix's shiny exterior were not limited to race or class. Air quality grew worse; by the seventies, the city often had a yellow haze over it and suffered from smog inversions in the winter. Phoenix also suffered from a high crime rate. The 1976 car bomb murder of Don Bolles, the *Arizona Republic* investigative reporter, was only the most dramatic evidence of continued organized crime. The immediate perpetrator, John Harvey Adamson—a wanna-be made man who frequented the Central Avenue cocktail lounges—was caught and convicted, along with two accomplices. But the crime was never solved to most people's satisfaction. It happened during an outbreak of other gangland violence, including the bombing of a witness a year earlier. Some pointed to Kemper Marley Sr., the wealthy liquor distributor and rancher. But the allegations were never

Canals remain the city's lifeline. Here, the Arizona Canal intersects with the Crosscut Canal in the Arcadia district in 1990. *James Eastwood, Library of Congress.*

proven. Nor did they make sense, for Marley was powerful enough to place a call to the *Republic* if he had a problem with a reporter, not plant a bomb. The event was a sign of larger disquiet. "Old Man Pulliam" had died a year earlier; the old stewards were passing from the scene and the city was changing fast—too fast for some.

ASCENT TO METROPLEX

Margaret Hance was born in Iowa in 1923 but came to Phoenix as a child. Terry Goddard, the son of Arizona governor Sam Goddard, was born in Tucson in 1947. Together, although as adversaries, they would transform Phoenix politics and lead the city into a new era. Implementation of mayor and council policies, of course, fell to city managers, and Phoenix was fortunate to have two respected, long-serving such officials, Marvin Andrews and Frank Fairbanks.

When Hance was elected mayor in November 1975, she was not, as is often claimed, the first woman to lead a major city. That marker goes to Bertha Knight Landes, elected mayor of Seattle in 1926. Hance was second, and her tenure was far more consequential. A pragmatic conservative Republican, she earned the deal making and policy chops in the preservation of the Phoenix Mountains that would later serve her as mayor. Her parks work made her an ideal city council candidate for the CGC, which was predicated on at least the appearance of selfless public service, not politicians. Widowed in 1970 at the age of forty-seven, she was also looking for a new challenge. She put the final stake in the CGC in 1975 when she ran independently for mayor, without the CGC's endorsement, and won handily. In truth, she had plenty of help.

In the late 1960s, Milton Graham broke the CGC's unwritten rule when he ran for a third and then fourth term for mayor. The CGC disowned his fourth run, and he lost, but the ethic of public service over career politics was shattered. Also, the CGC was tired, and the city had outgrown it.

Hance ran on a law-and-order platform. As the economy recovered from the 1974 recession, Hance easily got behind the growth machine. Her leadership looked a lot like the CGC's "businessmen's government"—only without the CGC. Taking plenty of funds from Washington allowed her to maintain her low-tax pledge (this did not keep her from inveighing against "the evils of federal money"). As so often happened in fast-growing Phoenix, a considerable amount of needed infrastructure was postponed indefinitely. Also like the CGC, she adamantly opposed district representation.

Hance was reelected three more times. No mayor in memory had served so long. On the national and local levels, she was Phoenix and vice versa. Hance was popular and connected. She was also very capable in the sharp-elbows department, usually using surrogates so her fingerprints were not at the scene. Yet she was also a mentor to a number of young comers, including Margaret Mullen, Martin Shultz and future U.S. senator Jon Kyl. She had her hair "done" daily and enjoyed a stiff drink early. The mayor's police detail originated with an officer being ordered to drive Her Honor so she wouldn't get in a boozy wreck, as had happened twice with Governor Jack Williams (a former Phoenix mayor himself).

While Phoenix grew north and west, Hance presided over considerable damage downtown and in the central core. Jane Jacobs's teachings were far from her skillset. Instead, she led the continued destruction of the Deuce by expanding the brutalist Phoenix Civic Plaza and building the sunblasted, dehumanized Patriots Square. In both cases, this required the bulldozing of many irreplaceable historic buildings, the bones of a walkable city with a new shop's door every few paces, the fine-grained human scale. On Hance's watch as a council member, the priceless Fox Theater had been demolished to make room for a city bus terminal that looked as if it had been rejected by Maryvale's architects. "The Mother of the Mountain Preserve" did not raise a protest. Further teardowns began in the capitol district, and the template was set: tear down old buildings in the core, even if it left vacant lots for decades. One exception during the Hance years was creation of Heritage Square as a haven for preserved buildings.

Thanks to Civic Plaza, the hardcore male vagrant population scattered into nearby areas, from the old central business district to the lawns of what are now the midtown historic districts. The beautiful grass and trees surrounding the old Carnegie Library became "Hypodermic Park," a haven for addicts and crime. A downtown businessman complained that one hobo would camp out daily in front of his shop and defecate on the sidewalk. Repeated calls to the police and the mayor's office brought no help.

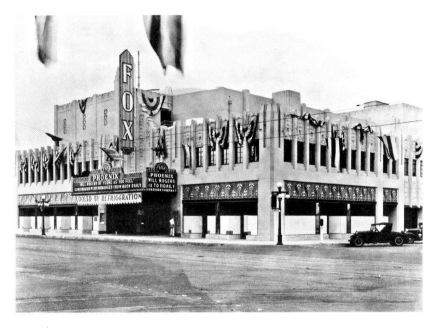

The most ornate of Phoenix's pre-World War II movie palaces was the Fox Theater. *Luhrs Family Photographs, Arizona Collection, Arizona State University Libraries.*

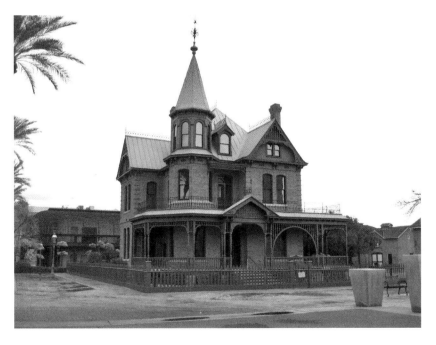

Rosson House is among the historic structures preserved at Heritage Square. *Greg O'Beirne, Wikimedia Commons.*

In the seventies, Phoenix planners vowed that Bell Road, a two-lane desert thoroughfare thirteen miles north of downtown would be the absolute boundary of the city. It didn't take long for subdivisions to leap across like a wildfire, and annexation was the city's prime policy. A long strip annexation battle was fought on the west side as Phoenix sought to prevent being hemmed in. The "urban village" and "Central Corridor" plans looked good on paper but failed in practice.

Goddard had moved to Phoenix and become a lawyer and civic activist. His major cause was to democratize city politics away from the control of the business elite, named the Phoenix Forty in the seventies. In 1982, he successfully oversaw a push to have council members elected from districts rather than at large. The next year, he was elected mayor and served through 1990. Goddard was the most urban-savvy mayor in the city's history; he had read and absorbed the lessons of Jacobs. Revitalizing downtown and the central core became a priority. So did saving the old neighborhoods north of downtown, which were given the designation and protection of historic districts.

By the late 1980s, the former farm towns around Phoenix were on their way to becoming supersized suburbs. For example, Mesa's population

Inside the restored Orpheum Theater, the only one of old Phoenix's movie palaces that was spared the wrecking ball. *Conrad Schmitt Studios. Wikimedia Commons.*

was 152,404; Tempe, 106,919; Scottsdale, 88,622; and Glendale, 97,172. Although Phoenix's population was almost 790,000, it no longer enjoyed the dominance of the previous decades. This played out as cities used annexation to gather sales tax dollars. Goddard called the zero-sum game "blood sport," but municipal leaders had little choice; this was the primary source of city revenues in Arizona. Phoenix and Scottsdale fought a particularly bitter running war to the north. Scottsdale Fashion Square was growing into the largest mall in the Southwest and taking valuable business from the region's central city. Phoenix succeeded in pushing all the way to the western edge of Scottsdale Road. In the coming years, this would allow it to profit from such developments as the mixed-use Kierland Commons, which had a Phoenix address and sent taxes to the city while claiming Scottsdale's growing cachet. Nor could Phoenix count on easily landing other assets. In 1980, Intel built its first semiconductor fabrication plant in Chandler.

Still, corporate Arizona remained centered in central Phoenix, and companies such as Valley National Bank, Arizona Public Service (APS), Central Newspapers (publishers of the *Republic*, *Gazette* and others in the midwest), Dial (renamed from Greyhound), First National Bank, the Arizona Bank, Western Savings and others not only sustained well-paying jobs but also played essential roles in philanthropy.

Midtown Phoenix looking north, 2015. *Michael Ging.*

APS also spearheaded and became part owner of the Palo Verde Nuclear Generating Station, which began operations in 1986. The largest nuclear station in the United States and a major source of power to San Diego, Los Angeles and Arizona, Palo Verde's three reactors are cooled by effluent water from valley cities. Constructing the station was controversial, especially in a location that put it forty-five miles upwind from downtown Phoenix. But the desire to continue building a major metropolis trumped the state's small and embattled environmental movement, as it would continue to do.

Goddard attempted to channel growth in a smarter, more sustainable way with his Futures Forum, where citizens were invited to participate in planning as part of an ambitious year-and-half-long program. Citizens had plenty of concern, partly thanks to a series on growth in the *Arizona Republic*, which included a report from national urban expert Neal Peirce. It was a devastating critique of the sprawl that was destroying the city's fabric, imposing huge hidden costs and undermining civic culture. Yet these efforts, although prophetic, came to nothing.

The Collapse of 1990

Through the '70s and '80s, the metropolitan area ramped up a building frenzy at a velocity that outstripped even the '60s. The Central Corridor saw new skyscrapers. Speculative office parks and warehouses spread out. Most significant was the emergence of the "master planned community," enormous residential developments that, although often within city boundaries, were largely separate entities with subdivisions governed by home owners associations (HOAs) that gained legal standing. Among the first were the Lakes in Tempe; McCormick Ranch in Scottsdale; Ahwatukee, south and east of the South Mountains and annexed by Phoenix; Arrowhead Ranch in Glendale; and Dobson Ranch in Mesa. In many cases, the "ranches" had been real agricultural properties, including vast acres of citrus. The old valley was giving way to the new. Yet much of it was built on a fragile financial footing.

Congress had allowed the stodgy savings and loan industry much more regulatory leeway in the '80s. As a result, savings and loan associations went on a lending binge for a national real estate boom. It was especially pronounced in Phoenix. So profitable was the business that APS established a holding company, Pinnacle West Capital, that allowed it to set up a thrift called MeraBank. It became the state's largest association. Western

Savings, controlled by the pioneer Driggs family, became deeply involved in speculative real estate lending. The most prominent player, however, was Cincinnatian Charles Keating, who arrived in 1976. Keating took over struggling American Continental Homes and made it into a powerhouse, renamed American Continental Corporation. Among his signature projects was the Phoenician, a luxury resort. Although located within the city limits, its stationery and promotional materials said "Scottsdale." He also platted the huge Estrella Mountain Ranch, a master planned community south of tiny Goodyear on the west side, leapfrogging the urban footprint and laid out on both sides of the Gila River. In 1984, he used junk bonds from Michael Milken's Drexel Burnham Lambert to purchase Lincoln Savings and Loan in California. Keating filled a leadership vacuum left as the old business elite faded or, as in the case of the younger Karl Eller, faced business challenges. Keating was notable, however, in his lack of civic stewardship aside from donations to Catholic charities. With a headquarters on east Camelback Road, Keating did nothing for the central core aside from patronizing the venerable Durant's restaurant on Central. He was not shy about donating to politicians to get his way.

In December 1988, the financial magazine *Barron's* published an article entitled "Phoenix Descending: Is Boomtown USA Going Bust?" Always defensive, local boosters issued especially angry denunciations. But the story was spot on: the valley was the epicenter of a massive Ponzi scheme about to crash. It came tumbling down in 1990, punctuated by federal charges against Keating and his involvement in the Keating Five scandal, where the financier tried to buy influence with five senators, including Arizona's Dennis DeConcini and John McCain. The failure of Lincoln alone cost taxpayers $3.4 billion.

For Phoenix, the 1990 crash was the worst economic downturn since the Depression. It hung over the city for years as the federal Resolution Trust Corporation became the most important entity in the valley, liquidating failed institutions and disposing of foreclosed properties. Among the worst casualties was Western Savings, one of the largest thrifts in the west and a valuable corporate headquarters. APS was deeply wounded, laid off large numbers of employees and never again played its former leadership role. So was the Central Corridor. With the completion of a dramatic Dial headquarters tower (two were intended) in 1991, no more skyscrapers would rise there, and new office activity moved elsewhere.

Around the same time, Phoenix was losing other important headquarters. The Arizona Bank was bought in 1986 and First National a few years later,

both by out-of-state institutions. In 1993, Bank One acquired Valley National, the city's most consequential corporate steward. Also in the 1990s, Dial was targeted by an influential Wall Street money manager, forced to cut back and eventually breaking up. In only a few years, Phoenix had lost its economic and civic-stewardship crown jewels. No other American city of this size was so damaged by the mergers and consolidations of the era. The contraction also drove most of the old builders out of business or to drastically cut back. National homebuilders came to dominate the market, a process completed when Pulte Homes acquired Del Webb Corporation in 2001.

The recession also slowed a host of central-city improvements spearheaded in the Goddard years, but they were gradually completed as the economy improved. Among them were America West Arena, moving the Suns downtown; a new city hall; and the Burton Barr Central Library designed by architect Will Bruder. The Rouse Company's mixed-use Arizona Center, an attempt to bring retail back downtown, opened in 1990. It did benefit from

The Burton Barr Central Library—funded by a 1988 bond issue and designed by Will Bruder—is one of the city's most distinctive buildings. *Bill Timmerman.*

two new mid-rise office towers occupied by APS and Snell and Wilmer. The retail section was initially a success but gradually declined under competition from suburban malls.

Nearby, the Mexican-themed Mercado, a partnership between soon to be governor Fife Symington and Chicanos Por La Causa, was even less successful. Symington was forced from office when he was indicted on charges of wrongdoing, in part swindling a union pension fund in the Mercado development. President Clinton pardoned Symington in 2001. Before the Mercado, he left a bigger mark on Phoenix with the Esplanade in 1983. Backed by savings and loan money, he proposed a large complex of mid-rise office buildings and a Ritz-Carlton hotel at Twenty-Fourth Street and Camelback in a low-rise neighborhood that had been partly rural into the sixties. Opposition forced some modifications, but the project gained city approval despite previous vows to keep taller buildings within the Central Corridor. More towers came to the area, with its proximity to Scottsdale and Paradise Valley. And midtown, which had hollowed out downtown, was in turn hollowed out. Unlike Los Angeles, with its multiple downtowns, Phoenix lacked the deeper economic strength to sustain its growing number of speculative office centers. "It's the hunter-gatherer mentality," developer Jim Pederson said, reflecting from the mid-2000s. "The mindset is use it up and move on."

The Victory of Freeways

Although state transportation planners had pressured Phoenix since the end of World War II to move forward with freeways, progress was slow. In 1960, the city adopted an ambitious freeway plan prepared by Wilbur Smith & Associates, one of the nation's leading transportation planning firms. But a decade later, only the Black Canyon and Maricopa Freeways were completed, making an L west and south of downtown. A motorist could drive all the way from Flagstaff to Tucson on Interstate highways, but that was it. Interstate 10 was building from California and reached Tonopah, fifty miles west of downtown Phoenix, by the early 1970s. There it connected with two-lane rural roads and highways.

In reality, Phoenicians were ambivalent about freeways. They didn't want their garden city "to become another L.A." Attitudes turned to hostility when the design of the inner loop of the Interstate 10 Papago Freeway was

unveiled. It featured the expressway crossing Central Avenue one hundred feet in the air and above neighborhoods of historic bungalows just north of downtown. Towering "helicoils" would provide the on- and off-ramps. In addition to being put off by the highway itself, Phoenicians then lived in a mostly single-story city where views of the mountains were everyone's due. Voters soundly defeated the inner loop in 1973 and attitudes were cool toward the entire Wilbur Smith plan. Around this time, citizens also revolted against freeways in Portland, Oregon, and Seattle, Washington.

Yet at this critical juncture, Phoenix leaders offered no alternatives. The professional city staff and much of the city council were hostile to transit. Funding for buses fell so low that Sunday service was canceled. Nor was city hall receptive to suggestions that Interstate 10 join the Maricopa Freeway at the Durango Street curve, south of downtown, rather than cutting through Phoenix's historic heart. Meanwhile, even with wider streets, traffic became worse as the decade wore on. The year 1985 proved a historic turning point when county voters approved a half-cent sales tax increase to pay for a regional freeway system. This was a larger voting base than the city election of 1973 and consisted of many people who had not even lived in the valley for long. Most were frustrated with long commutes.

After years of fighting freeways, today's Phoenix has one of the nation's most extensive systems. This is the Stack, where Interstates 10 and 17 meet, west of downtown. The Sierra Estrella are in the distance. *Shutterstock*.

Another critical moment was the defeat of ValTrans in 1989, a proposal that would have greatly enhanced bus service and built commuter train lines. The city's still-intact business elite widely supported it, as did the *Arizona Republic* and *Phoenix Gazette*. The outcome showed the diminishing power of what had been the establishment.

By the turn of the new century, almost all the Wilbur Smith plan was completed. The Interstate 10 inner loop was finished in 1990; a compromise put six blocks of it under a deck park. Kenilworth School was saved, and the remaining neighborhood revived. Still, three thousand homes, many of them priceless historic houses dating from before statehood into the twenties, were demolished. By the 2000s, Phoenix had one of the most extensive urban freeway networks in the nation.

THE COMEBACK

Phoenix's economy rebounded in the nineties for many reasons. The Greater Phoenix Economic Council (GPEC) was established to diversify the economy and, under the leadership of Ioanna Morfessis and backed by the remaining business stewards, made initial progress. Nationally, the recession was slight, and Americans continued moving to the Sun Belt. By many measures, the national expansion was the strongest in the postwar era. The growing freeway system proved to be an economic stimulus itself, not even primarily in road-building jobs. New expressways made farmland and desert suddenly valuable for subdivisions. The first big success was with the Loop 202 Red Mountain Freeway that replaced citrus groves in Mesa with housing. The growth machine appeared to work like never before. For the decade ending in 2000, Maricopa County grew more than 40 percent. The urban footprint leaped out of the Salt River Valley, running some 1,500 square miles south to Queen Creek and into Pinal County; north to exclusive north Scottsdale in the foothills of the McDowell Mountains and to Del Webb's Anthem master planned community; and west to Buckeye, which would claim a planning area of more than 300 square miles on the west side of the White Tank Mountains.

Newcomers had more leisure choices than ever before, too. The St. Louis Cardinals of the National Football League had come in 1988, initially carrying the name Phoenix and then Arizona. A decade later, the city won

The miles of curvilinear subdivisions are symbolic of Phoenix and its suburbs. *Shutterstock.*

a Major League Baseball team, the Arizona Diamondbacks, playing in an air-conditioned stadium downtown. A National Hockey League team, the Phoenix Coyotes, relocated from Winnipeg and played in the same downtown arena as the NBA Suns.

The Phoenix Symphony, begun in 1948 as a volunteer ensemble, was a fully professional orchestra by the nineties. A block from Symphony Hall, the Herberger Theater Center hosted professional stage companies. Katherine "Kax" Herberger emerged as the most important arts patron of this era, also endowing the College of Fine Arts at ASU. The Phoenix Art Museum, under the direction of James K. Ballinger, rose from modest beginnings to become one of the top city art museums in the west. In 1996, it opened a new building and ended up occupying almost all of the former civic center at McDowell and Central.

The agricultural magic of the valley was largely lost for all the fortunes made in real estate. Developers built shopping strips, apartments and subdivisions along the length of Baseline Road, leaving the Japanese flower gardens as only memories. And that was for a diminishing minority. Metro Phoenix experienced tremendous population churn as well as growth. As time went on, fewer even remembered the garden city. Another loss was passenger train service. When the state would not

The Herberger Theater Center was another late 1980s project to revive downtown. *Wikimedia Commons.*

kick in money to help the Southern Pacific (then Union Pacific, after a merger) maintain the northern main line, the railroad put the western section out of service. Phoenix became the largest city without Amtrak service in 1996.

Another shift came in the relationship between the metropolitan area and the Indian reservations that bracketed it on the east and south. In 1993, Indian Gaming compacts were signed with the state, and tribal casinos opened soon after. Early to the gambling market and neighboring prosperous Scottsdale, the Salt River Pima-Maricopa Indian Community began ending decades of isolation and poverty. After the turn of the century, the Salt River and Gila River Indian Communities developed resorts to compete for tourist dollars. With the settlement of water rights on top of gambling revenues, these near-urban tribal communities would become increasingly powerful in the metropolitan area.

The final element that ensured recovery was an enhanced and seemingly even more secure water supply.

TAPPING THE COLORADO

Arizona had lusted for what it saw as its share of the Colorado River since statehood. But powerful California had the first straw in the river, and bringing its water to central Arizona seemed to face insurmountable political, legal and engineering barriers. Winning the Central Arizona Project (CAP) became the life's work of Senator Carl Hayden, son of Tempe's founding father Charles Trumbull Hayden. He was the state's first congressman, serving until 1927. Then he was elected to seven terms in the U.S. Senate, amassing enormous influence in a body governed by seniority. The CAP (pronounced by its letters, not like a hat) united the state's congressional delegation for decades.

Arizona repeatedly sued California, always unsuccessfully. Then, in 1957, Governor Ernest McFarland made the controversial decision to remove the eminent John Frank as the lead lawyer in the latest *Arizona v. California*. As a U.S. Senator, "Mac" had spent years fighting for the CAP. As governor, he chose the gifted litigator Mark Wilmer, assisted by Charlie Reed of Pinal County. The two embarked on a radically different and risky legal strategy, arguing the case all the way to the Supreme Court. In 1963, Wilmer and Reed prevailed. Arizona was granted a substantial share of the river's water as well as all of the Gila River.

In 1968, President Lyndon Johnson signed legislation authorizing construction of the $4 billion Central Arizona Project, the last great reclamation project. It was also one of the most impressive feats of civil engineering in history, taking the water at Lake Havasu, pumping it over a mountain range and into a 336-mile canal to Phoenix and Tucson. The system lifts the water nearly three thousand vertical feet. Construction began in 1973, survived an attempt by President Jimmy Carter to kill the CAP and was completed twenty years later.

The rationale for the CAP was initially to take the state's "fair share" of the Colorado and send it to largely agricultural uses outside the Salt River Project. Reclamation was tougher outside the rich soil and river system of the Salt River Valley, and for decades, groundwater had been badly depleted, including in Tucson. But by the time the CAP was authorized, it became clear that it would heavily benefit urban expansion. Interestingly, this was an argument California had made against the CAP, warning it could endanger the river's supply by creating an unsustainable population explosion in central Arizona. The CAP proved to be a cornerstone of the growth machine's

hyper expansion. Even in the sixties, Hayden and some others who worked to gain the CAP began to have misgivings about its potential to destroy the magic of the valley by drawing millions of newcomers.

The state's agricultural industry remained powerful and held many senior water rights. Many farmers made fortunes turning their land over to suburban development. However, as subdivisions covered the nutrient-rich alluvial soil of the valley, growers moved into less hospitable regions of the metropolitan fringes, Pinal County and Yuma. Continued productivity depended partly on using more water and fertilizer than was necessary in the Salt River Valley.

Some protection, however, appeared to be built into the landmark Groundwater Management Act, signed into law by Governor Bruce Babbitt in 1980. Among other things, it sought to stop groundwater pumping and require new exurban developments to show a one-hundred-year water supply. It established a state Department of Water Resources to enforce the rules, as well as Active Water Management Areas, with close monitoring of water use, in Phoenix, Tucson and other populous areas.

The CAP and Groundwater Act seemed to put to rest any question about secure water supplies. And people were voting with their feet, moving to metropolitan Phoenix in record numbers.

LIFE IN THE BUBBLE

Phoenix entered the twenty-first century as the nation's sixth-largest city. But very different dynamics were in play than when the city began its star turn in 1960. It was part of a metropolitan area with more than three million people and surrounded by supersuburbs, or "boomburbs," that effectively competed against the city for tax dollars, state revenue sharing, economic assets and political influence. Unlike residents of virtually every other major metropolitan area, Phoenicians tended to say they were from "the Valley" rather than using the central city's name. While Scottsdale, the East Valley and other suburbs prospered, Twenty-Fourth Street and Camelback attracted new offices and condos; the city's biggest economic win, a large USAA back office, was placed in far north Phoenix. Downtown was mostly inert. Jobs also fled once-prosperous midtown. Park Central had closed as a shopping mall in the nineties. Enormous tracts of land were empty in the core, resulting from the demolition of hundreds of buildings, including those of historic importance. The old city, and much of Phoenix's authenticity, was going fast. Not only that, but the core was lifeless at a moment when history was turning again and downtowns were making impressive comebacks around the nation. But not in Phoenix.

Other cracks began to become evident. Journalism revealed the hidden costs of the "clean industries" recruited after World War II. Many of the city's aquifers, its emergency water supply, had been polluted from decades of high-tech waste. Pollution concerns existed in South Phoenix and elsewhere. Cancer clusters were documented in Maryvale, once Phoenix's

shining example of the American Dream. Twelve Environmental Protection Agency Superfund sites are located in the metro area.

Many found the endless sea of red-tile roofs and news that the metro area had the largest number of gated properties in the nation troubling. Among the most influential pieces of journalism in this regard was an *Arizona Republic* series reporting that runaway development was consuming an acre of desert every hour. Hohokam ruins and centuries-old saguaros were bladed with no checks. Civic culture had crumbled in most of the valley as people kept moving and were separated by walls and gates—and by inclination. Many newcomers didn't consider Phoenix home but rather a disposable community. News stories lamented the lack of leadership. "Resort culture" was not always good, for one would do something on vacation that he or she would never try at home. No wonder Phoenix badly lagged behind other cities in giving to charities and the arts.

As Grady Gammage Jr., a real-estate lawyer and scholar of the region's growth, put it, "the consensus around the growth machine collapsed." An initiative to establish growth boundaries was put on the November 2000 ballot, and polls showed that it enjoyed wide support. This news caused a hysterical and urgent response from the many players that benefited from unchecked horizontal building. Elliott Pollack, the city's most prominent economist and a developer himself, asserted that passage of the measure would cause a recession. A well-funded advertising campaign painted it as "the Sierra Club measure" as if it were a fringe cause, and supporters reported campaign signs being ripped down and being intimidated. Growth boundaries were defeated in the election.

In the aftermath, the growth interests went on their biggest expansion yet, reaching north into Yavapai County and south toward Tucson. Once-rural Buckeye and Pinal County became epicenters of major subdivision construction. Speculative office parks, tilt-up warehouses and shopping strips came out of the ground at a fast rate. Because Phoenix was one of the most "over-stored" metros in the country, one result was that even recently built big boxes or retail strips were abandoned for newer properties. Behind the new boom was the national force of easy money from the Federal Reserve and a deregulated banking sector making subprime home loans, often ones that required little or no documentation of the credit-worthiness of the buyer.

People kept voting with their feet, arriving at a rate of more than 100,000 a year, and Phoenix enjoyed some of the nation's strongest job growth. This cloaked troubles. Among them were low per-capita and median household incomes, high poverty, poor funding for schools, continued cutbacks in

university funding, lower levels of college degree holders than peer metros and the emergence of miles of linear slums in what had once been middle-class subdivisions. The city was increasingly the "hole in the donut," with most of the region's working poor and aging infrastructure, while economic growth occurred in newer annexed suburbs within the city, such as far-north Desert Ridge.

Even boosters worried about the region's narrowing economy, how it was dependent on construction while legacy industries such as Motorola faded away. Intel continued to invest but manufacturing employment in the metro area fell dramatically. After initial success at GPEC in the early nineties, Ioanna Morfessis left as her corporate chief executive supporters' companies were bought and the impetus to build a quality economy faded. Assessing the situation in the 2000s, she said, "We're drunk on growth." Thus, any serious effort at reinvention was set aside.

Nor did the CAP guarantee water security. Drought set in, and the Colorado River was oversubscribed. Groundwater pumping continued in central Arizona. Subdivisions were proposed for portions of the state with little if any groundwater. Tensions emerged as the Verde Valley northeast of Phoenix became an exurban building hotspot, encroaching on water claimed by the Salt River Project. Questions were raised about the rigor with which the state was managing and enforcing water requirements for new developments.

With the old business leadership gone and the remains of corporate Arizona moving to the Scottsdale Airpark, five important figures emerged and fought for a better metro area and state. They were Janet Napolitano, the new and popular Democratic governor; Michael Crow, who became president of Arizona State University (ASU) in 2002; Suns and Diamondbacks managing partner Jerry Colangelo; and two Phoenix mayors, Skip Rimsza and Phil Gordon.

Arizona had voted for Bill Clinton in 1996, but predictions that newcomers would transform it into a "purple" or even a "blue" state proved wildly wrong. Instead, the state became more conservative and Republican. To be sure, voter turnout was low. But the conservatives had superior organization and funding. Self-selection among the Anglos, what journalist Bill Bishop and sociologist Robert Cushing called "the big sort," caused conservative-leaning immigration while liberals went elsewhere. Mormons were a powerful and engaged voting bloc for the conservatives. Hispanic voting rates, potentially liberal, were extremely low. This played out in a split between cities and suburbs, even in historically Democratic

Tucson. Phoenix was becoming a more liberal city, but it often faced opposition from deeply conservative suburbs.

Napolitano was narrowly elected in 2002, backed by a silent majority of sorts, "the sensible center," she called it. Although a pragmatist and conservative in many policies, she did institute an all-day kindergarten that helped children of the working poor. Reelected by a large margin four years later, she was forced to play defense against the GOP-controlled legislature. In reality, the governor was constitutionally weak in Arizona, and her more daring efforts were stymied. She did help in critical areas for cities and universities.

Colangelo, the last heir of the old Phoenix Forty (rechristened Greater Phoenix Leadership but without much influence), was a champion of downtown, although he also faced many critics because of city and county subsidies of arenas. With city help, he had brought three sports teams downtown and championed the area. The Coyotes decamped for a new arena in Glendale, which also won a taxpayer-funded stadium for the NFL Cardinals. It was a high-profile example of the cannibalization of assets within the metro area, especially suburbs taking them from the center city. For a time, Glendale appeared to score a coup with the sports facilities anchoring new development, including the Westgate shopping complex. It came to grief as Glendale was weighed down with debt. Considering the metro area's economic shrinkage, Colangelo doubted if it could long support four top-level pro teams.

Rimsza led several moves that helped bring downtown to a positive tipping point. The greatest potential came when Phoenix successfully lured the Translational Genomics Research Institute, or TGen, led by Jeffrey Trent, who had been part of the effort to decode the human genome and was from Phoenix. Along with the International Genomics Consortium, TGen anchored the new Phoenix Biosciences Campus on the old Phoenix Union High School site. A new medical school branch of the University of Arizona joined them. Trent hoped to replicate Houston's huge Texas Medical Center, which included hospitals, research institutions, medical schools and colleges of nursing, dentistry, pharmacy and public health. But help from the legislature came grudgingly, existing hospitals resisted and the campus grew slowly.

Tempe, under the leadership of Mayor Neil Giuliano, took the lead in resurrecting defeated plans for light rail. Rimsza joined in, and with last-minute help from Mesa, the three cities proposed a nearly twenty-mile starter line. This time, voters resoundingly approved it, federal funding

Phoenix launched a twenty-mile light-rail line in 2008 with extensions continuing. In 2013, passengers prepare to board a westbound train at Central Station. *Valley Metro Light Rail.*

came from U.S. representative Ed Pastor's lobbying of the George W. Bush administration, and despite some noisy opposition, the line opened in 2008. It proved highly popular, and extensions followed in the 2010s.

Gordon, who had represented central Phoenix on city council, became mayor in 2004. He saw through many of the initiatives begun by Rimsza, including the completion of a large, attractive new convention center (the old one had been smaller than that of Grand Rapids, Michigan). Most consequentially, he worked to bring an ASU campus downtown. Of all the fits and starts to revive the old core, this would prove the most important. ASU eventually moved its colleges of nursing, journalism and mass communication and law downtown. Light rail provided a convenient connection with the main campus in Tempe.

Coming from Columbia University and drawing a huge salary, Crow was immediately the subject of one question among the locals: how quickly will he leave? Instead, he stayed, implementing a plan for "the New American University," one that would successfully navigate falling state funding but build excellence and be accessible to students of all backgrounds. Although he built on the work of his predecessor, Arizona native Lattie Coor, Crow took the nation's largest public university to new levels of achievement. He

Arizona State University's downtown campus was developed in the 2000s. This is the Walter Cronkite School of Journalism and Mass Communication. *Walter Cronkite School of Journalism and Mass Communication.*

was a prodigious fundraiser, whether getting $50 million from New York real-estate magnate William P. Carey for the college of business or large sums from the federal government to the new biodesign institute. Crow also spoke the language of developers, an important skill in Phoenix.

The grass-roots approach also helped begin a very slow turnaround in the once-vibrant areas north of downtown. Artists had staked out inexpensive space downtown in the eighties, but demolition of buildings kept them on the move. Beatrice Moore was among the most prominent, eventually establishing a small art colony around Grand Avenue and Roosevelt. Farther east, between Third and Seventh Streets, Greg Esser, Cindy Dasch, Wayne Rainey and Kimber Lanning created studios and concert spaces for what would become Roosevelt Row. Its First Friday events became highly attended. Lanning became especially influential, working with the city to establish adaptive reuse codes and founding an organization dedicated to encouraging people to shop locally. And to the north of Roosevelt Row, the historic districts had become some of the most desirable neighborhoods in the metroplex.

These small steps of recovery in the core were lost amid the larger output of the growth machine. In July 2004 alone, nearly six thousand

The 1914 A.C. Redewill House, an example of preservation in the Willo Historic District. The author lived here in the 2000s. *Susan Talton.*

permits were issued for single-family houses. Prices for homes soared. House flipping, so prevalent that it inspired television shows, was especially popular in Phoenix. All local experts considered the situation sustainable. At worst, they said, a correction would return the housing market—which had become synonymous with the metropolitan economy—to normal.

The region was also confronted with immigration from Mexico, much of it illegal. This, along with a previous wave in the 1980s that won amnesty, was most disruptive to the old Mexican American community. Much of it had moved to Maryvale and other older subdivisions after the historic barrios such as Golden Gate were bulldozed for an expanding Sky Harbor International Airport (by the 2000s, one of the nation's busiest). Mexican Americans faced immigrant competition for jobs and overcrowding in already crowded and underfunded schools.

However, increasing numbers of Anglos became alarmed, and anti-immigrant sentiment rose. Even though many of the most ardent opponents of illegal immigration lived in virtually all-Anglo subdivisions, walled off from what some were calling "the Mexican Detroit" (the city of Phoenix),

An immigrants-rights march along Grand Avenue in 2006 drew an estimated 100,000 participants. *Susan Talton.*

they were concerned about the costs to taxpayers from educating and providing healthcare to illegals. While crime was actually falling in Phoenix, lurid tales were told of the drug traffickers and people smugglers who were using Phoenix as a national distribution center. However, the problem circled back to the American appetite for cheap immigrant labor. Hundreds died every year trying to make it through the desert for jobs in *el norte*.

Antipathy toward illegal immigrants became a potent political force. It survived a momentary challenge from Mexican Americans, who staged a march to the capitol in 2006 that drew an estimated 100,000 participants. In the aftermath, however, Latino voting remained low while anti-illegal immigrant Anglos grew more energized. Yet building a border wall and advocating mass deportation became almost beside the point when the worst economic crisis since the Great Depression struck. This time, Phoenix was ground zero.

THE GREAT CRASH
AND QUESTIONS

The Great Recession affected Phoenix more than any other similarly large metropolitan area in America or its peer competitors in the west. None of the others was so dependent on housing and speculative constructive of all types. House prices fell by 50 percent or more. Nearly 102,000 construction jobs were lost. Hundreds of thousands lost their properties to foreclosure or owed more on their mortgages than the value of their houses. Government revenue plummeted so drastically that in 2009 the state negotiated a "sale lease-back" of the buildings housing the legislature, as well as the executive tower. This lesser depression lingered in Arizona for years after the official end of the national recession.

Unlike the Great Depression, no New Deal was coming to Phoenix's rescue. The federal government instead embarked on austerity. Unlike the collapse of 1990, this one lingered as it did in the parts of the country with the most overbuilding and suburban sprawl. From the post-recession perspective, Phoenix looked more like a city from the past, from a unique moment in time, than a city of the future. Cities that prospered in the new, slow-growing economy were either oil powerhouses (Houston and Dallas) or technology centers (Seattle, Denver, Boston, Austin and San Francisco). They shared another common asset: vibrant downtowns. Both millennials and empty nest baby boomers with talent and means gravitated to central cities with good bones and jobs. Walkable neighborhoods and abundant transit were also in demand. Fewer young people wanted to own cars.

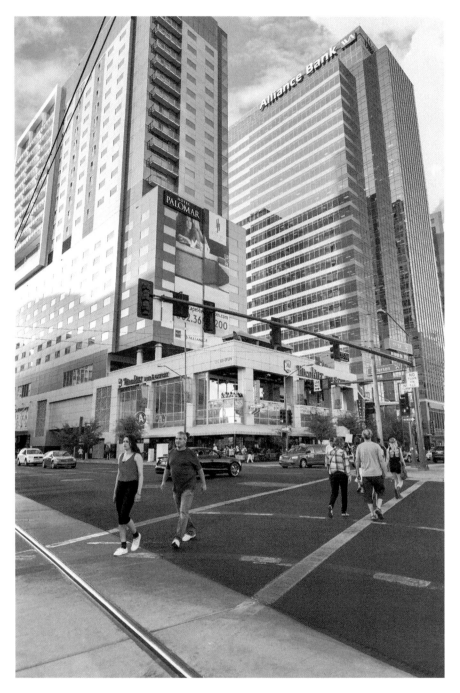

CityScape in 2011. The mixed-use development downtown included offices, a hotel, retail and restaurants. *CityScape Phoenix.*

These characteristics of what urban scholar Richard Florida calls "the great reset" fit the Phoenix of 1950, right down to the scalable, localized economy that many critics of the highly-concentrated, neo-liberal order of the early twenty-first century advocate. Those qualities did not apply to the Phoenix of 2010. To be sure, downtown made some progress, with continued growth of the ASU campus and the completion of the CityScape mixed-use project. When the 2015 Super Bowl was played in Glendale, the NFL made downtown Phoenix the center for game-related events. Some construction picked up in the core, both on Roosevelt Row and along the light-rail line.

In 2011, the book *Bird on Fire: Lessons from the World's Least Sustainable City* was released by the Oxford University Press. Author Andrew Ross, professor of social and cultural analysis at New York University, conducted a trenchant but impeccably researched analysis of Phoenix's situation. He raised questions that were virtually forbidden among local boosters, and the condemnations of Ross became a cottage industry. Of particular sensitivity were questions about water and climate change, as well as reminders of how growth does not pay for itself. Beyond that, he asked if the region had overshot its carrying capacity. His questions remain urgently relevant, not only to the city but the nation, even though the local zeitgeist is to somehow restart the growth machine. As of 2015, it hadn't happened, certainly not to the degree necessary to recover the momentum of the past.

Phoenix is a very different city. In 2010, it was almost 41 percent Hispanic, more than ten percentage points higher than the state and much higher than the affluent suburbs. It had been around 14 percent Hispanic in 1960. A large underclass suffers from poorly funded schools. The city is not growing as fast as its boomburbs. That doesn't mean it won't likely overtake Philadelphia as the nation's fifth most populous city again. But a deeper examination will not find it number five in any measure of a quality economy, from venture capital and startups to high-wage employers—or fifth in cultural assets, education or social advancement. The action, such as it is, has shifted along the 101 Freeway from north Scottsdale to Chandler. But the sum is not enough to pay the carrying costs of such a large metropolitan area, much less compete against similarly sized metros in advanced nations for talent and capital.

In 2012, Greg Stanton became the fifty-ninth mayor of Phoenix. Smart and genial, Stanton supported city improvements as a councilman. As mayor, he made regional cooperation a priority. A promising new city manager, Ed Zuercher, took office in 2014. In addition to backing extensions of light

rail, Stanton was partnering with ASU's Michael Crow on a potential ASU school of medicine at the Mayo Hospital in far north Phoenix.

The city remains sunny and pleasant much of the year, although overnight temperatures have risen more than ten degrees over the past fifty years and the summers last longer. The annual monsoons bring towering thunderheads and, sometimes, blessed rain. The air is enchantingly perfumed by orange blossoms in March, the ghost of the American Eden that once was and, for many, remains. Self-immolation may be the Phoenix's destiny, but optimism is the ruling emotion for most Phoenicians. For them, it is enough to defeat even complex problems, with history itself a river that can always be tamed and channeled for progress.

SELECTED BIBLIOGRAPHY

Abbott, David R., ed. *Centuries of Decline During the Hohokam Classic Period at Pueblo Grande*. Tucson: University of Arizona Press, 2003.

August, Jack L., Jr. *Dividing Western Waters: Mark Wilmer and Arizona v. California*. Fort Worth: Texas Christian University Press, 2007.

———. *The Norton Trilogy*. Fort Worth: Texas Christian University Press, 2013.

———. *Vision in the Desert: Carl Hayden and the Hydropolitics of the American Southwest*. Fort Worth: Texas Christian University Press, 1999.

Collins, William S. *The Emerging Metropolis: Phoenix, 1944–1973*. Phoenix: Arizona State Parks Board, 2005.

Farish, Thomas Edwin. *History of Arizona*. Vol. 6. San Francisco: Filmer Brothers, 1918.

Foster, David William. *Glimpses of Phoenix: The Desert Metropolis in Written and Visual Media*. Jefferson, NC: McFarland & Co. 2013.

Gammage, Grady, Jr. *Phoenix in Perspective: Reflections on Developing the Desert*. 2nd ed. Tempe: Arizona State University, 2003.

Horton, Arthur G. *An Economic, Political and Social Survey of Phoenix and the Valley of the Sun*. Tempe, AZ: Southside Progress, 1941.

Luckingham, Bradford. *Phoenix: The History of a Southwestern Metropolis*. Tucson: University of Arizona Press, 1989.

Osselaer, Heidi J. *Winning Their Place: Arizona Women in Politics, 1883–1950*. Tucson: University of Arizona Press, 2009.

Reisner, Marc. *Cadillac Desert: The American West and Its Disappearing Water*. New York: Viking Penguin, 1986.

Ross, Andrew. *Bird on Fire: Lessons From the World's Least Sustainable City*. New York: Oxford University Press, 2011.

Seargeant, Helen H. *House by the Buckeye Road*. San Antonio, TX: Naylor, 1960.

Sheridan, Thomas E. *Arizona: A History*. Revised ed. Tucson: University of Arizona Press, 2012.

Shermer, Elizabeth Tandy. *Sunbelt Capitalism: Phoenix and the Transformation of American Politics*. Philadelphia: University of Pennsylvania Press, 2013.

Towne, Douglas. "A Bridge to Remember." *Phoenix Magazine*, February 2013.

VanderMeer, Philip. *Desert Visions and the Making of Phoenix, 1860–2009*. Albuquerque: University of New Mexico Press, 2010.

Worster, Donald. *Rivers of Empire: Water, Aridity and the Growth of the American West*. New York: Oxford University Press, 1985.

Zarbin, Earl. "'The Whole Thing Was Done So Quietly': The Phoenix Lynchings of 1879." *Journal of Arizona History* (Winter 1980).

Index

About the Author

Jon Talton is a fourth-generation Arizonan and the author of eleven novels, including the David Mapstone Mysteries set in Phoenix. He also writes the Phoenix-centric blog "Rogue Columnist." A thirty-year veteran journalist, Talton worked for the *Rocky Mountain News*, the *Dayton Daily News*, the *Cincinnati Enquirer* and the *Charlotte Observer*. He was also a columnist for the *Arizona Republic* and is now the economics columnist for the *Seattle Times*.

BOOKS BY JON TALTON

The David Mapstone Mysteries:
Concrete Desert
Cactus Heart
Camelback Falls
Dry Heat
Arizona Dreams
South Phoenix Rules
The Night Detectives
High Country Nocturne

The Cincinnati Casebooks:
The Pain Nurse
Powers of Arrest

Other Fiction:
Deadline Man: A Novel